This is
Goya

Published in 2015 by
Laurence King Publishing
361–373 City Road
London EC1V 1LR
United Kingdom
T +44 20 7841 6900
F +44 20 7841 6910
enquiries@laurenceking.com
www.laurenceking.com

A catalogue record for this book is available
from the British Library.

ISBN: 978 1 78067 616 6

Series editor: Catherine Ingram

Printed in China

This is
Goya

WENDY BIRD
Illustrations by SARAH MAYCOCK

LAURENCE KING PUBLISHING

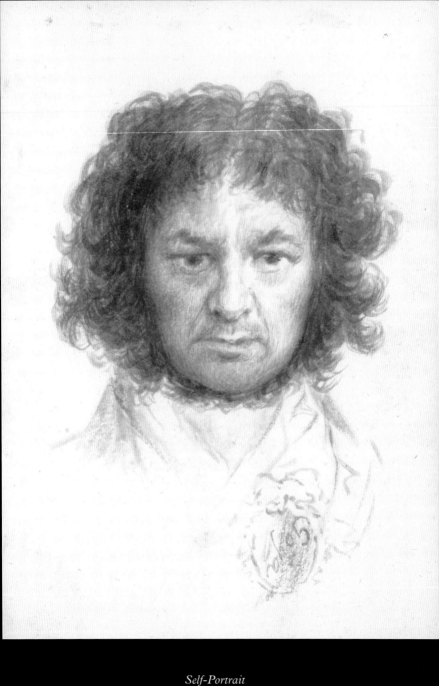

Self-Portrait

Francisco de Goya y Lucientes, 1795–97

Brush and greywash on laid paper, 15.3 × 9.1 cm (6 × 3⁹/₁₀ in)
Metropolitan Museum of Art, New York.
Harris Brisbane Dick Fund, 1935. Acc.n.: 35.103.1

Francisco de Goya y Lucientes was the first artist deliberately to pursue creating works of art for their own sake. Modern art begins with Goya. Straddling the eighteenth and nineteenth centuries, he lived in a time of incredible cultural and social dynamism.

In this striking self-portrait, Goya is in his early fifties and at the height of his career. The unsentimental documentation of his own face and character recalls Rembrandt's own images of himself, and Goya acknowledged the seventeenth-century Dutch master as an important influence. Other influences he cited were the Spanish master Velázquez and nature.

Within a decade of this image, Goya would see his comfortable, progressive world turned upside down and ripped apart by Napoleon's armies, who supposedly represented the new concept of equality. Afterwards he would also suffer the reactionary backlash of the restored Spanish monarchy.

But Goya's art rises above the chaos of his times, and signals the real revolution of personal expression and independent spirit that would be the generative force behind the Modernist movement in art.

Goya's Madrid

In the late eighteenth century Enlightenment thinking and new scientific enquiry were challenging old views across Europe. But in Spain Catholicism retained an iron grip, and acknowledging the ideas of thinkers such as Isaac Newton and René Descartes was tantamount to heresy. The king, Charles III, was known for his pious rigidity, and his son Charles IV would prove a lazy and uninterested despot.

But modern ideas did still succeed in filtering into Spain. Both Charles III and Charles IV recognized the need for urban regeneration and wanted to be patrons of a modern art. They were also absorbed in the period's mania for collecting and categorizing the natural world: Charles III ordered his fleets to source the best and most extraordinary natural wonders from around the world, and during the reign of his son a new Museum of Natural History (now the Prado) became one of Madrid's centrepieces.

Goya would feed on and reflect these first sparks of an enlightened Spain. The Madrid of his youth and middle age was a modern, optimistic city, where the sun always shone, and Goya recorded its panorama of street life. His real fascination was with the human form and human expression – especially as he saw it in the world around him.

Those attracted to Enlightenment ideals were called *afrancesados* (Francophiles), as the French were perceived by the Spanish establishment as being the source of these modernisms. Goya was an *afrancesado*, and would follow the latest French fashions, dressing with a fabulous sense of style. A fashion alternative was the *majo* style, which was based on a romanticized idea of Spanish gypsy culture. Goya and his circle of friends could easily slip back and forth between the two styles, depending on whether they wished to stress their pride in their Spanish culture or their aspiration to a more modern world.

But Goya's life did not begin in Madrid …

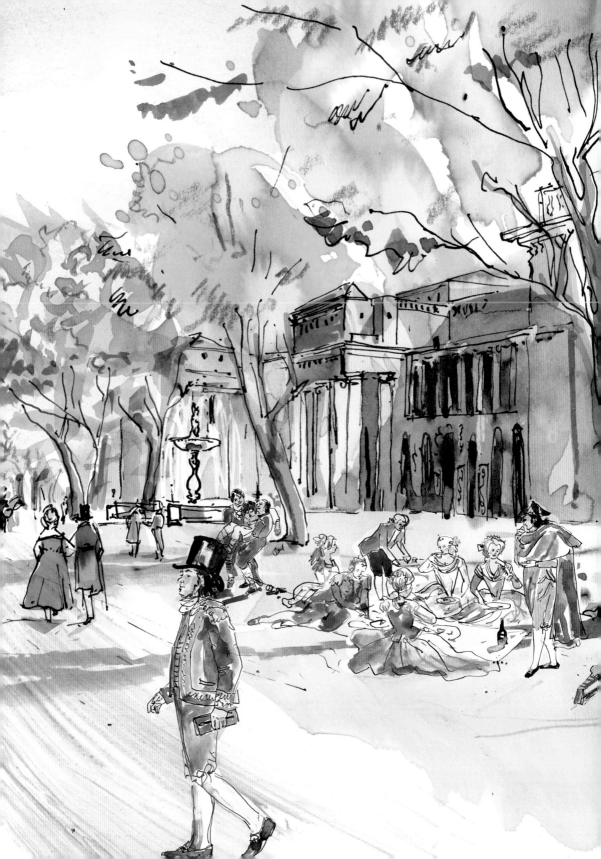

Born with a gilded spoon ...

Francisco José de Goya y Lucientes was born on 30 March 1746 at his grandparents' house in the quiet country village of Fuendetodos in Aragón. He grew up in the nearby city of Saragossa, with its many churches, monasteries and cathedral. His father, José, was a master gilder, and Saragossa was the right place to find work, as religious art required gold frames and embellishments. And José had good contacts.

Not much is known of Goya's early years. He had two sisters and three brothers, and like any other boy of the time he would have played with others in the streets and countryside. By 1756, aged 10, Francisco was helping his father and his associate Juan Luzán gild church organs.

Goya was lucky enough to receive a formal education free of charge at the *Escuelas Pías* in Saragossa. One of his classmates there was Martín Zapater, with whom he developed a lifelong friendship. In 1759 Goya's father sent him to work under José Luzán. Goya stayed there four years. It was there that Goya first encountered the brothers Manuel, Francisco and Ramón Bayeu. Goya would become firm friends with them, and work a great deal with Francisco and Ramón during the early part of his artistic career. Also, he would later marry their sister Josefa.

This was a close-knit artistic community; José Luzán's brothers and father were gilders, like Goya's father. Luzán taught Goya to use prints as a basis for his paintings, and by the age of 16 Goya had been commissioned to paint a reliquary for the church of Fuendetodos. By the time he left Saragossa in 1763 his profession as an artist was fixed.

The hunter

Much of what is known about Goya is thanks to his lifelong correspondence with his schoolmate and friend Martín Zapater. His many letters were preserved by Zapater and describe his development and success as an artist. But they also provide many intimate details of his thoughts and everyday life. In his letters to Zapater, Goya often reminisced about their youthful hunting expeditions in the countryside around Saragossa. Goya preferred an active outdoor existence, and hunting would remain a favourite pastime throughout his life.

Despite Goya's affinity with nature, it would rarely serve as the primary focus of his art. His main concern was human behaviour. However, his love of hunting was something he would share with his many aristocratic patrons, especially members of the royal family. Goya's reputation as a proficient marksman contributed to his status among these important patrons.

In 1763 Goya left Saragossa for Madrid, where he is known to have worked temporarily in Francisco Bayeu's studio. Goya encouraged Zapater to join him in Madrid, but not to visit the city itself: rather to hunt quails and partridges, which were plentiful in the surrounding countryside.

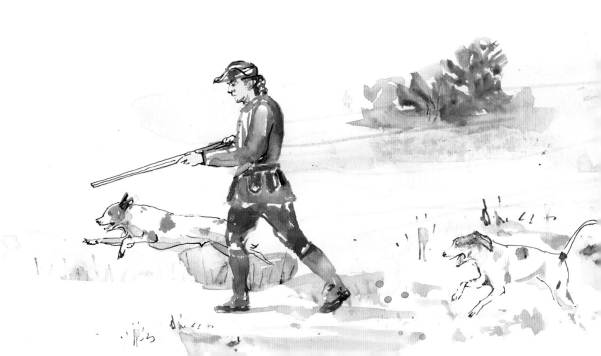

Tales from Italy

Radical artist tempts nun.

Goya goes to Italy

To really get on in Madrid any professional artist needed to become a member of the Royal Academy of Fine Arts of San Fernando, but the competition for places was tough. Goya's early years in the city were spent trying to gain entry. However, it was not Goya but his friend Ramón Bayeu who won the prize in 1766. (Goya himself would not become an academician until 1780, with a very traditional composition of the Crucifixion.)

After several years of trying to gain some position, Goya decided to improve his artistic education by a painting tour of Italy. He would stay there for three years. Little is known about his life there, though the Goya mythology is peppered with fanciful tales.

At the time academic art was in the Neoclassical style and much teaching consisted in copying plaster casts of Classical sculptures or male nudes in the same poses. Rome was full of canonical works with which every up-and-coming artist had to be familiar, and Goya absorbed this tradition. His Italian notebook contains sketches of a number of the mandatory sculptures, including the two famous Classical sculptures of Hercules in the Vatican: the Belvedere Torso and the Belvedere Hercules. But there were also scenes in the street and other unusual sights: a carnival mask, a donkey's head looking through a window, and a cat. These enigmatic-sounding images anticipate the next stage of Goya's career.

Spanish artist graffitis St Peter's.

Goya hangs out with bullfighters.

La Pepa

Goya returned relatively triumphant from his Italian sojourn.
In 1773 he married the Bayeus' sister Josefa – whom he always
called 'La Pepa'. For a man whose life is illuminated by the
letters he wrote to others, and those that were written about him,
surprisingly little is known of Goya's marriage with La Pepa. But
they lived together for almost 40 years until her death in 1812.
And even in the sparse references to her in his letters, Goya's
affection for his wife is evident, as it is in the few drawings he
made of her.

However, home life wasn't all comfort. Pepa suffered many
miscarriages and stillbirths. At least seven children were born
alive, but only one, Xavier, survived beyond infancy to adulthood.

Goya would often joke with Zapater (who remained unmarried)
about his visits to brothels. And he famously had a passion for
the Duchess of Alba in middle age, but it seems unlikely that the
passion was ever reciprocated. In the end, during Pepa's lifetime
the only woman in his life seems to have been his wife. And
whatever his joking about carousing with his male acquaintances,
his married life was essentially a happy one.

Soon after his marriage, Goya started receiving commissions –
often in conjunction with his Bayeu brothers-in-law. And in 1775
Goya and Ramón Bayeu were summoned by the director of the
Royal Tapestry Factory of Santa Bárbara in Madrid.

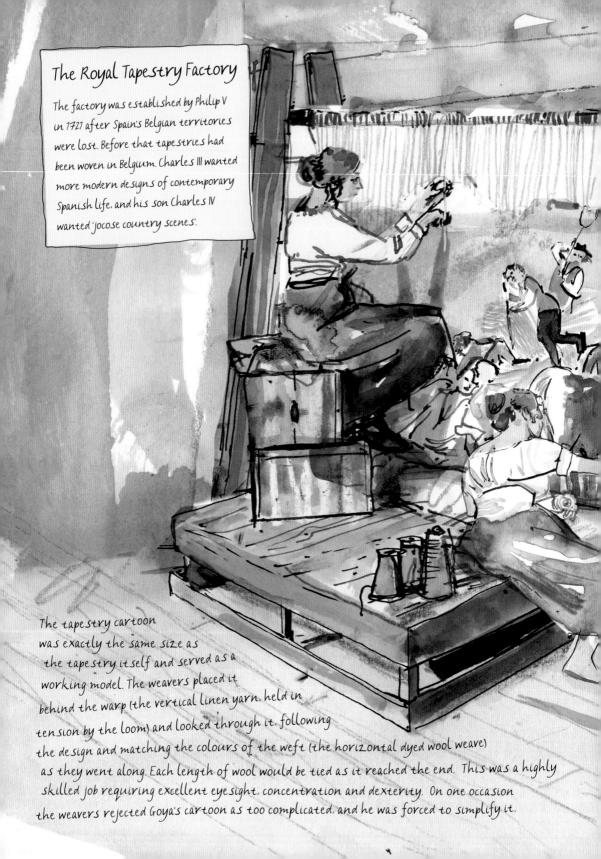

The Royal Tapestry Factory

The factory was established by Philip V in 1721 after Spain's Belgian territories were lost. Before that tapestries had been woven in Belgium. Charles III wanted more modern designs of contemporary Spanish life, and his son Charles IV wanted 'jocose country scenes'.

The tapestry cartoon
was exactly the same size as
the tapestry itself and served as a
working model. The weavers placed it
behind the warp (the vertical linen yarn, held in
tension by the loom) and looked through it. following
the design and matching the colours of the weft (the horizontal dyed wool weave)
as they went along. Each length of wool would be tied as it reached the end. This was a highly
skilled job requiring excellent eyesight. concentration and dexterity. On one occasion
the weavers rejected Goya's cartoon as too complicated. and he was forced to simplify it.

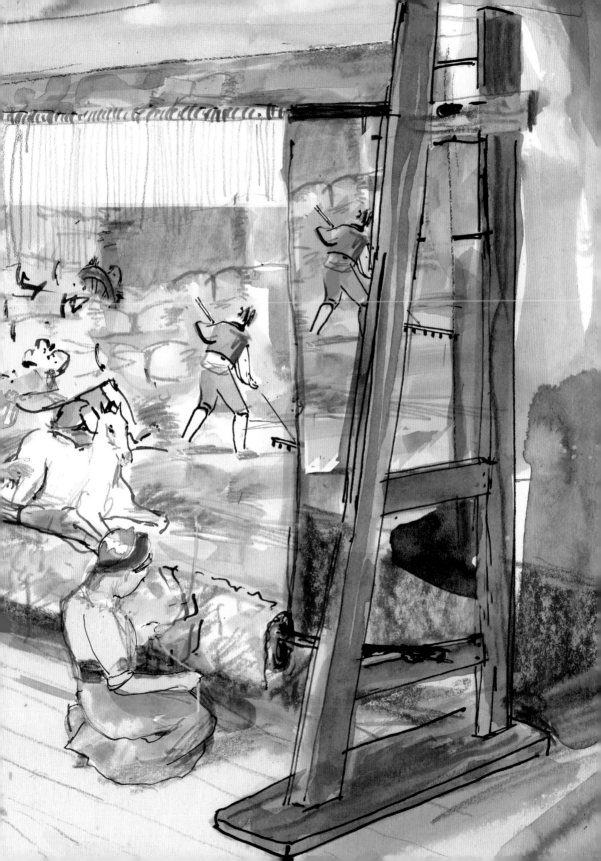

The Royal Tapestry Factory

In 1775 Goya and Ramón Bayeu, both aged 28, were summoned to work at the Royal Tapestry Factory of Santa Bárbara in Madrid under the supervision of Francisco Bayeu, who was already a painter at the court of the king, Charles III. Once again, the Bayeu family was taking steps to further their brother-in-law's career.

The return to Madrid was a great opportunity, and this time Goya was working for the Royal Court. Between 1775 and 1792 he would produce 63 cartoons for tapestries for the royal palaces of San Lorenzo de El Escorial and El Pardo. Goya would paint colour sketches for approval by the supervisor before executing the full-size model for the tapestry workers to work from. The pastoral scenes were to show hunting, dancing, picnics and games in the open air, projecting a positive image of enlightened Spain.

Goya's first tapestry commissions were for eight hunting scenes. *Hunting with a Decoy* is a disconcerting image, with the submissive dog and the decoys: the strange wide-eyed owl and caged goldfinch, which attract small birds into the ominous net. This piece of royal art resonates with the age in which it was made, and the crown's obsessive collecting of natural curiosities. The caged animals look like dislocated scientific specimens, echoing the status of those extraordinary beasts caged and shipped home from the colonies. More eerily still, the caged birds are probably taxidermy. The staring owl derives from paintings by Bosch in the royal collection, which influenced the Surrealists. What makes this image particularly odd is the placing of caged animals in a natural scene and this incongruity also has a Surrealist flavour. In 1774 Charles III had created a primitive zoo for his colonial beasts in the Parque del Buen Retiro, and recently art historians have argued that Goya at one point painted the park's giant anteater. Goya, like many of Madrid's citizens, would have visited the park, one of the first zoos in Europe, and the sight of caged beasts in a botanical (albeit artificial) setting might have inspired this very odd painting.

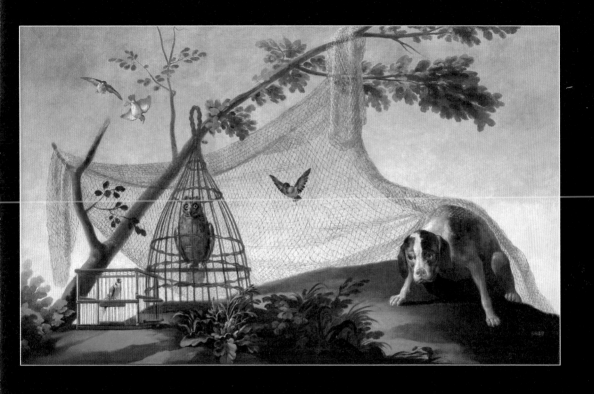

Hunting with a Decoy
Francisco de Goya y Lucientes, 1775

Oil on canvas, 112 × 179 cm (44⅛ × 70½ in)
Museo del Prado, Madrid

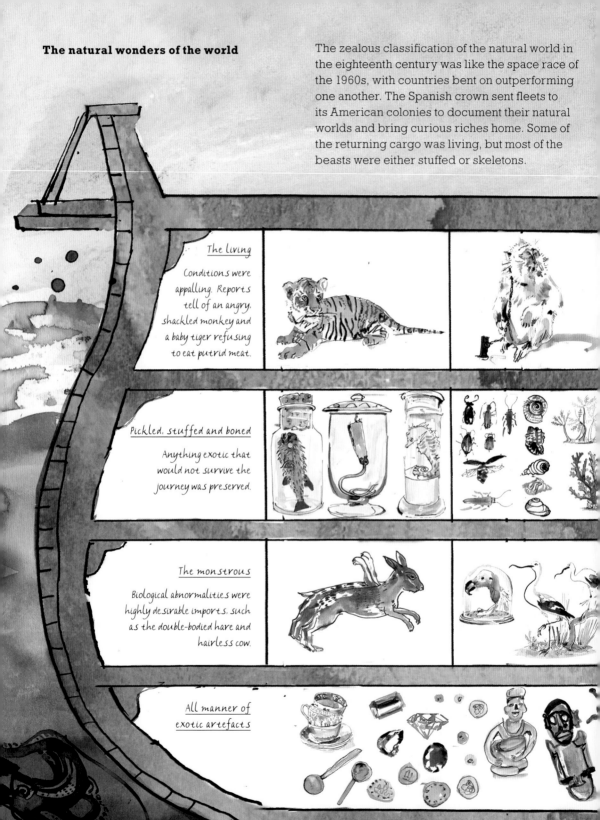

The natural wonders of the world

The zealous classification of the natural world in the eighteenth century was like the space race of the 1960s, with countries bent on outperforming one another. The Spanish crown sent fleets to its American colonies to document their natural worlds and bring curious riches home. Some of the returning cargo was living, but most of the beasts were either stuffed or skeletons.

The living

Conditions were appalling. Reports tell of an angry, shackled monkey and a baby tiger refusing to eat putrid meat.

Pickled, stuffed and boned

Anything exotic that would not survive the journey was preserved.

The monstrous

Biological abnormalities were highly desirable imports, such as the double-bodied hare and hairless cow.

All manner of exotic artefacts

The pickled and stuffed specimens became part of Charles III's Natural History Cabinet, while the living beasts roamed his park. As court painter to Charles III and Charles IV, Goya would have seen the royal collections. The Spanish collecting mentality – in particular, this obsession with the extraordinary – would echo through Goya's work.

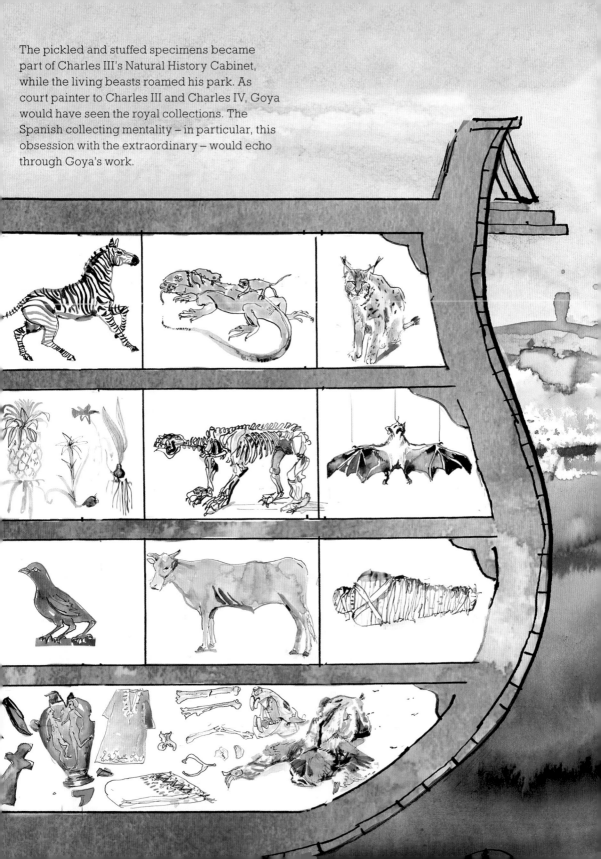

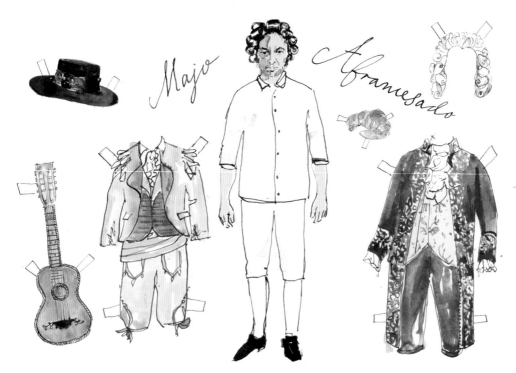

Majo

Afrancesado

Goya the *majo*

After five years, in 1780 royal funding for tapestry series suddenly dried up (it would begin again in 1783). Francisco Bayeu then recruited Goya and Ramón to return to Saragossa to decorate the city's cathedral. However, Goya's work was criticized by the cathedral authorities – some of the female figures were 'not as decent as they should be'. Francisco was asked to 'correct' them. Goya lost his temper. One of the monks warned him not to pick a fight or he would be seen as a 'vain and difficult' man, as Bayeu was 'the premier artist of the day, whereas you (although perhaps more talented) are merely a beginner …'

Goya returned to Madrid and immersed himself in the exhilaration of city life. Through his work at the factory (and probably also through his promotion by his brothers-in-law) Goya was known at court. At court he would have dressed quite elegantly, in the French style. However, when he was away from the court he sometimes dressed in the *majo* style. An expression of Spanish national pride, *majismo* was inspired by a romanticized gypsy lifestyle and was soon adopted by members of the aristocracy and court for non-formal occasions. Goya even painted himself once in *majo* attire: a short matador jacket, lace-fronted shirt, long hair loose rather than in a pigtail. This was dressing up, but it gave him a sense of freedom. He also owned a *tiple*, a small Aragonese guitar, and collected the latest popular songs, which he would share with Zapater.

'My own invention'

Back in Madrid, Goya soon received a royal commission for an altarpiece in the Church of San Francisco el Grande. 'Bayeu the Great', wrote Goya sarcastically, was to paint another. This would show '… those vile men who have so doubted my worth', and he included a proud self-portrait in the painting. His brother Camilo wrote of the envy that surrounded his success: '… they cannot bear that he should be so highly praised or should be so highly regarded compared with the rest.'

Work resumed on the tapestry cartoons, but Goya now felt he could do better. From 1776 he had been describing his paintings as 'from my own invention', but these were models for tapestries, not works of art in their own right. Goya's job was to show people having fun in the sunlit realm of 'the good old king', but the task was becoming tedious. Goya now sought portrait commissions from the aristocracy.

The enormous tapestries in Luis Paret's *Charles III Dining before the Court* show how important they were as wall coverings. Charles is receiving his courtiers, all of whom are standing, since only the dogs could sit. Paret was court painter to Charles's younger brother, Cardinal Don Luis de Borbón, but when accused of procuring prostitutes for him, he was exiled to Puerto Rico. Don Luis rescinded his religious vows and married. His court was banished to Arenas de San Pedro, a hundred miles from Madrid. In 1783 and 1784 Goya was summoned there to paint portraits of his family … and to go hunting.

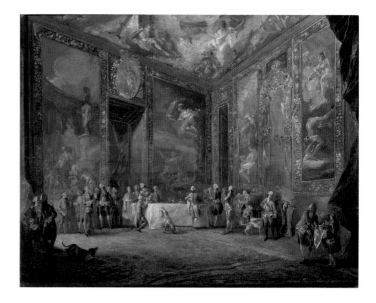

Luis Paret y Alcázar
Charles III Dining before the Court, c. 1775
Oil on panel, 50 × 64 cm
(19¹¹⁄₁₆ × 25³⁄₁₆ in)
Museo del Prado, Madrid

'This could be worth a lot to me'

In January 1783 Goya received the most important commission of his career so far, a portrait of the chief minister to Charles III, José de Moñino, Count of Floridablanca, who had commissioned the paintings for San Francisco el Grande.

Goya wrote to Zapater:

> … don't tell anyone, my wife knows and I'd like only you to know … this could be worth a lot to me. I owe so much to this gentleman. I was with his lordship for two hours after dinner …

Described by an English traveller, the count was '… a little man, and, if I may judge by his eyes, exceedingly hypochondriacal …'

By including a self-portrait of shorter stature than the count, Goya makes this 'little man' look tall. His fashionable pigtail looks lower-class, while the count wears a distinguished wig. His dark clothes are unobtrusive in contrast with the count's splendid gold-embroidered vermilion velvet suit and oyster satin waistcoat with sky-blue shot silk sash. Goya shows him a painting up to which he holds a magnifying glass, but he stands frontally and with a stern expression stares straight ahead. This emphasizes his electric-blue eyes, which struck the traveller in the above description. A smiling portrait of the king hangs behind him, a tired-looking court official below, and the large clock, which stands among papers, maps and books on the desk, marks 10.30 in the evening, to show how hard the count works for his people.

Perhaps Goya tried too hard to aggrandize his patron. Months later he wrote to Zapater:

> My friend, there is no news and even more silence in my dealings with Sir Moñino than before I did his portrait and I wouldn't dream of bothering him, since I have been advised by cautious men and they all tell me that his silence and not having heard from him is a good sign; the most he said to me after having served him was 'Goya, we'll meet again when there's more time,' with which I can tell you no more.

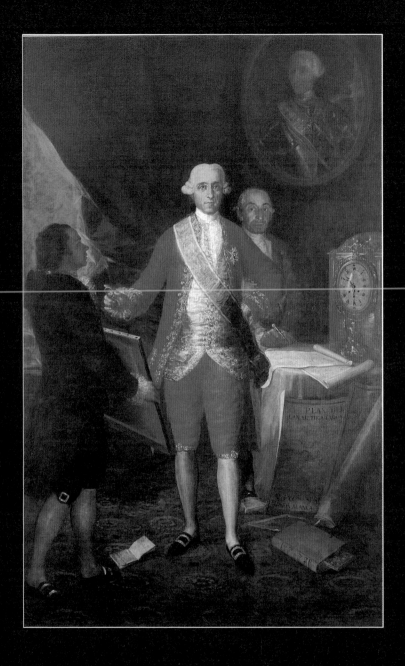

José de Moñino, Count of Floridablanca,
with Goya and the Architect Francisco Sabatini
Francisco de Goya y Lucientes, 1783

Oil on canvas, 260 × 166 cm (102⅜ × 65⅜ in)
Collection of the Banco Urquijo, Madrid

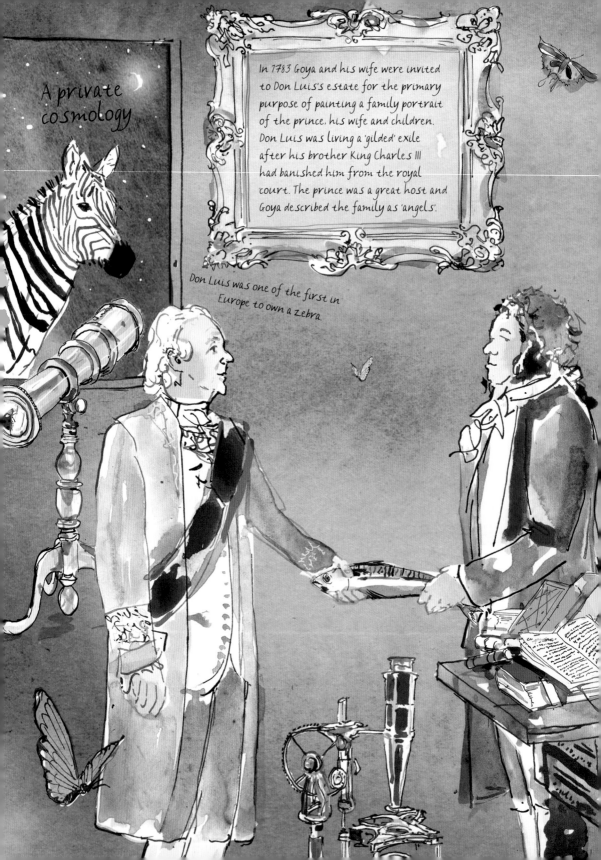

A private cosmology

In 1783 Goya and his wife were invited to Don Luis's estate for the primary purpose of painting a family portrait of the prince, his wife and children. Don Luis was living a 'gilded' exile after his brother King Charles III had banished him from the royal court. The prince was a great host and Goya described the family as 'angels'.

Don Luis was one of the first in Europe to own a zebra.

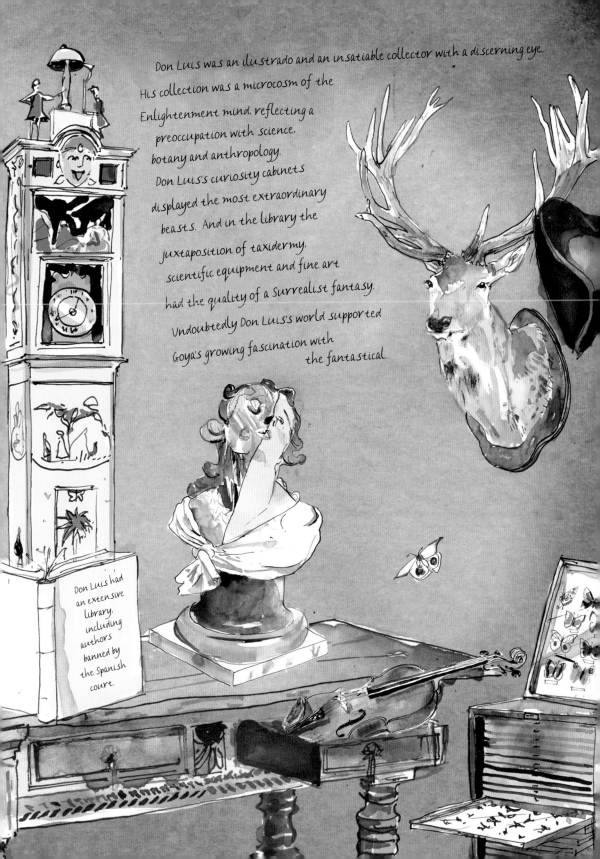

Don Luis was an ilustrado and an insatiable collector with a discerning eye. His collection was a microcosm of the Enlightenment mind, reflecting a preoccupation with science, botany and anthropology. Don Luis's curiosity cabinets displayed the most extraordinary beasts. And in the library the juxtaposition of taxidermy, scientific equipment and fine art had the quality of a Surrealist fantasy. Undoubtedly Don Luis's world supported Goya's growing fascination with the fantastical.

Don Luis had an extensive library, including authors banned by the Spanish court.

The informal portrait

It is evening at the court of Don Luis de Borbón, who is playing cards with his wife while she has her hair done. A single candle illuminates her white gown, pale face and black-eyed gaze. It reflects off objects that cast deep shadows, bringing to mind theatrical light effects.

The other figures all stand but, like the privileged dogs in Paret's painting of Charles III, Goya is the only courtier seated, his back to the viewer in the act of painting, his face in profile.

The composition draws on the tradition of the Spanish court as a family. It makes reference to Velázquez's great group portrait 'The Family of Philip IV', later retitled *Las Meninas*. Like Velázquez, Goya includes himself as a member of the family.

And as with *Las Meninas*, one of the children comes to see the artist work, the little blonde María Teresa, peeping round the canvas. Her older brother, Luis María, stands upright behind his sagging father, their features in profile contrasting youth and age.

As with *Las Meninas*, the family is accompanied by members of their court. The tall Italian cellist Luigi Boccherini, court composer, has a distinctive profile. The governess holds the baby María Luisa Fernanda and two ladies-in-waiting hold Doña María's bonnet. The portly gentleman is the secretary. The man with a bandaged head is waiting to have a wig fitted. His relaxed stance and wide grin contrast with the resentful mien of the court painter Alejandro de la Cruz, who was never commissioned to paint the family's portrait. No doubt this is what Goya was referring to when he boasted: '… other painters have not managed to do this …'

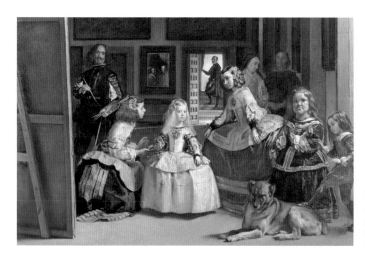

Diego Velázquez
Las Meninas (detail), *c.* 1656

Oil on canvas, 318 × 276 cm
(125³⁄₁₆ × 108¹¹⁄₁₆ in)
Museo del Prado, Madrid

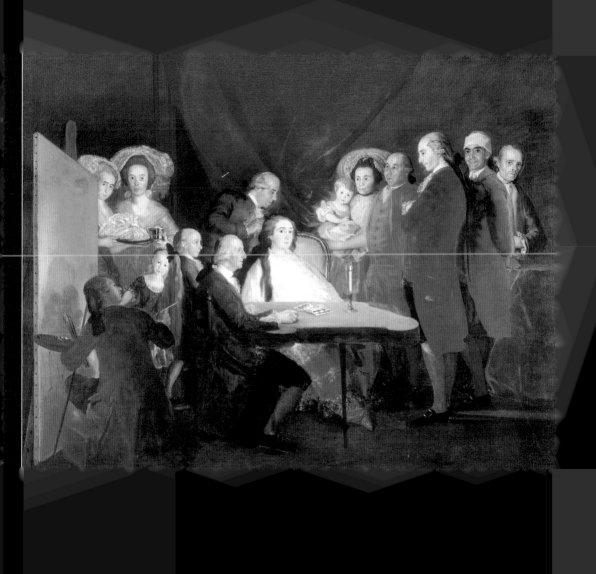

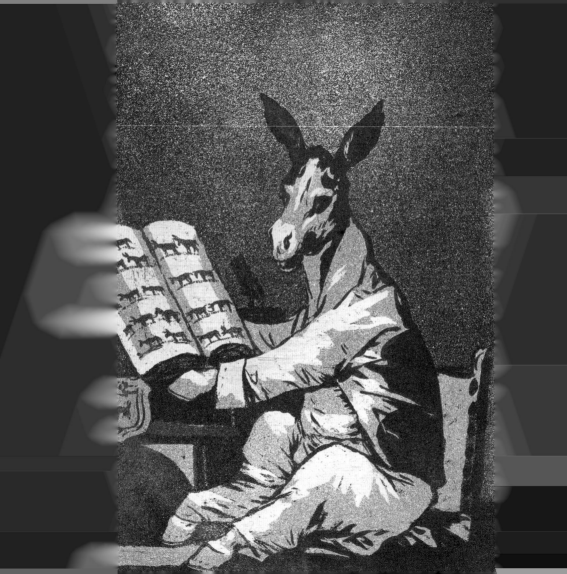

Painter to the king

In 1786, at the age of 40, Goya was appointed court painter to Charles III, and when Charles IV succeeded his father in 1788, Goya retained his position with an increase in salary.

Also, from 1785 Goya was assistant director of painting at the Royal Academy.

'I had such an enviable way of life', he wrote. '… If anyone wanted anything from me they came to find me', and 'unless it was a high class person … I didn't work for them.'

Goya was getting on well in high society and had conceived the notion that he too might be entitled to high social status. In 1790 he began a search for noble ancestry anywhere in his family, but failed to discover anything at all.

Many years later, when he was producing his famous *Caprichos* series of prints, he would send up his younger self's vainglorious social climbing by depicting a donkey proudly displaying his family tree and revealing … donkeys all the way back!

As painter to the king, Goya would have had fairly easy access to the royal collections – the king's fabulous botanical and zoological prints and his curiosity cabinets full of wonders from the natural world. The collections also held some of the best works by the sixteenth-century Flemish painter Hieronymus Bosch, whose hellish visions may well have helped Goya to invent his own visual language to capture the mindless horror of war and man's cruelty. Bosch's demonic part animal, part human monsters strangely echoed the Spanish obsession with the extraordinary, and resonate in the invented beasts of Goya's own art.

Goya's new carriage

Goya celebrated his appointment as painter
to King Charles III in 1786 by buying himself
a state-of-the-art tilbury carriage.
He had truly made it in Madrid.
and was not just the boy from
Saragossa any more.

'I'm limping from a fall I had from the gig ... it's
a real beauty (there are only three like it in
Madrid); it's English – made over there.
Wow, here people stop to look at it.'

The tilbury quickly led to
a series of accidents.

Goya's driver took him outside the city to demonstrate
how to turn at a gallop, but the 'gig, horse and us'
turned over and over.

A year later Goya had had enough:
'I don't want that fly any more. The other day I overturned it
and almost killed a man who was walking down the street,
and I didn't do very well out of it either. So I'm writing to my
brother Thomas to ask him to buy me a pair of mules.'

The Wedding

There was a change in Goya's work at this point, an uneasiness that had not been present in the earlier, light-hearted tapestry cartoons. This reflected changing attitudes in society, and people were beginning to look critically at tradition and traditional practices. These trends are reflected in Goya's new, restless and disturbing cartoons. The Spanish *ilustrados* (enlightened thinkers who supported progressive trends in science, art and social reform) never entertained the more radical ideas of the French Revolution, such as universal suffrage; their concerns were quite selfish. Many of them were wealthy landowners, and as such were primarily interested in land and trading reforms that could improve their profits and wealth. However, there was awareness among the *ilustrados* that social change was needed, and this is reflected in Goya's new 'edginess'. *The Wedding* is a satire on an old custom of marrying young girls to much older (and wealthier) men. Symbolizing the old order in a state of ruin, the scene is set in front of a crumbling, ancient stone arch and a 'grandfather' figure symbolically brings up the rear, hobbling his way down the broken steps.

Not for the first time in Goya's work, the scene resembles a play. In the centre, backlit by harsh white sunlight, are the bride – a pretty teenage girl, her hair in a bun, wearing a striking dark *maja* dress and white satin shoes with buckles – and the groom – a middle-aged man whose apelike features are a symbol of lust. He pulls at the girl's sleeve, breathing lecherously down her neck. A red-faced cleric with a bulbous nose puts his hand furtively into his cassock, a sign of corrupt dealing. He will have arranged the wedding.

Ahead of them is a man in a short *majo* jacket and three-cornered hat, accompanied by tramps and ragamuffins, playing a kind of oboe. One of the boys stands on top of a cart with his arms in the air, a sign of a cuckold's horns, symbolizing infidelity, a common outcome of marriages of convenience. The smiles are false, the bright sunshine and costumes incongruous.

Goya continued to paint tapestry cartoons for the royal palace at El Escorial, but he never did complete this final cycle of what his contract called 'humorous country affairs'. Within a year he was fighting for his life.

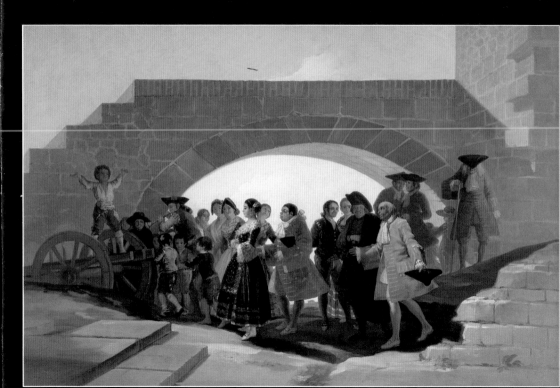

Deafness

By January 1793, Goya was on his way to Andalusia in the south – the birthplace of *majismo*. He had not applied for permission to travel, probably because he thought his absence from court would not be noticed.

There Goya was the guest of the wealthy silk merchant Sebastián Martínez. A self-made man, Martínez was a fellow *ilustrado* and friend. He was also an *afrancesado* (Francophile), and in 1795 would be reported to the Inquisition for owning 'indecent' artworks, although he managed to avoid prosecution.

Goya fell ill soon after arriving, and in a letter of March 1793 Martínez wrote that Goya was experiencing pain in the head, but a couple of weeks later he was recuperating: '… The noise in his head and deafness have not ceased, but he sees much better and does not suffer that disorder which made him lose his balance. Now he can go up and down the stairs very well …' Goya stayed at Martínez's until May 1793.

One convincing theory for this illness was that Goya was suffering from lead poisoning, particularly likely because of the dangerous amounts of white lead he used in his paints. In fact, the description of his illness matches one known at the time as 'artist's colic'. Goya would remain deaf for the rest of his life. He found living with such a handicap isolating: no more music, dancing and lively conversation.

Revolution

Yet during his six-month recuperation, Goya had time to reflect and to absorb new influences. Martínez's collection of French and English satirical prints included the complete engravings of Hogarth, and as a keen student of French politics, he owned prohibited French revolutionary pamphlets, all of which Goya would have had ample opportunity to familiarize himself with.

The French Revolution, which had begun in 1789, had by 1792 reached such a pitch that the Spanish Inquisition took charge of controlling the border to prevent the arrival of '… books, papers, prints, boxes, fans, notebooks and other things that represent the revolutions occurring in France'. For Spain's *ilustrados*, many of whom were aristocratic if not royal, it signalled both the change they had been waiting for and the end of their way of life. In January 1793 Louis XVI, first cousin to the king of Spain, was tried for treason and sent to the guillotine. And heads would continue to roll: no one connected to the royal family or in a position of power was safe. The court of Madrid was in turmoil and *ilustrados* would have to watch their step.

Capricho and invention

On 4 January 1794 Goya sent 11 small paintings on tinplate to the director of the Royal Academy in Madrid, along with a letter:

> In order to occupy my imagination, dispirited by the thought of my illness, and to compensate in part for the great expense it has caused me, I have been dedicating myself to painting a group of cabinet pictures in which I have managed to make observations that do not often appear in commissioned works and in which *capricho* [wit] and *invención* [originality] are not restricted.

For years Goya had wanted to paint innovative subject matter with complex meanings. He was hoping these paintings would be appreciated as such. Three days later he wrote to describe an addition to the series: '… a yard with madmen, and two of them fighting naked with the one who takes care of them by beating them and others with sacks (this is something I saw in Saragossa)'.

Like many things Goya wrote, the last statement should not be taken literally. Still convalescing, it is unlikely that he would have visited the Saragossa asylum, but he may have seen *The Madhouse at Saragossa* in the theatre. The scene is clearly 'staged' and the spectator looks down upon the action.

This 'theatre of the mad', drawing on traditions of 'the fool', may well represent the French Revolution, which Spanish observers saw as mass hysteria. 'The French have gone mad', wrote Goya's friend the playwright Leandro Fernández de Moratín, who was there at the time. The idea may well also have been inspired by Hogarth's *In Bedlam* of 1735.

Because of his deafness, Goya was released from the obligations of continuing to paint tapestry cartoons and his teaching at the academy, and could concentrate on his own projects and portraiture.

William Hogarth
In Bedlam from *A Rake's Progress*, plate VIII (detail), 1735

Engraving on heavy laid paper, State I/II, 35.6 × 40.8 cm (14 × 16⅛ in)
Brooklyn Museum, Bequest of Samuel E. Haslett, 22.1844

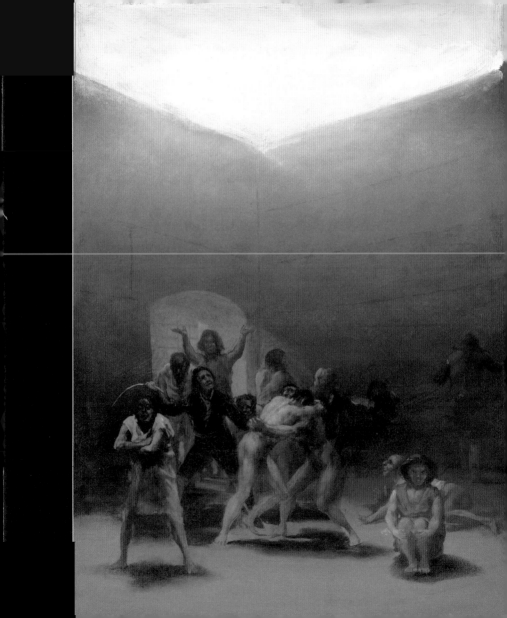

The Duchess of Alba

In the early 1790s Goya painted individual portraits of the Duke and Duchess of Alba, the highest grandees of Spain and great patrons of the arts. When in 1796 the duke died, the grieving duchess, for companionship, invited Goya and others to her house at Doñana near Cádiz, where he spent the summer – possibly staying as long as eight months. Goya would spend his time as a guest hunting and working on a second portrait of the duchess. He also painted two small humorous scenes of the duchess and two of her children pestering a servant. His own sketchbook he filled with drawings of women – some of a distinctly erotic nature.

In a letter to Zapater, Goya wrote: '… I have to portray her whole body …'; this was a *double entendre*. Even before his stay at Doñana, the duchess had become an object of desire for Goya, and to have access to her whole body was his fantasy.

Proof of Goya's passion for the duchess lies in his second portrait of her. She wears a black dress, but it is not a mourning gown. She strikes a flamboyant pose with left hand on hip, as if she were about to take some flamenco steps, with her tiny satin pointy-toed Cuban-heeled feet firmly on the ground, to which she points authoritatively. The rings on her fingers read 'Goya' and 'Alba'. Written into the sand below are the words *Solo Goya* (Only Goya). This last was discovered only during restoration in the 1950s.

In his later *Caprichos* prints Goya suggested that he had been led on by the duchess, but most likely, perhaps because of his hearing disability, he misinterpreted her friendliness towards him. On the other hand, the prints refer to a more complex web of intrigue and deceit, in which another of Goya's patrons, the prime minister Manuel Godoy, was implicated.

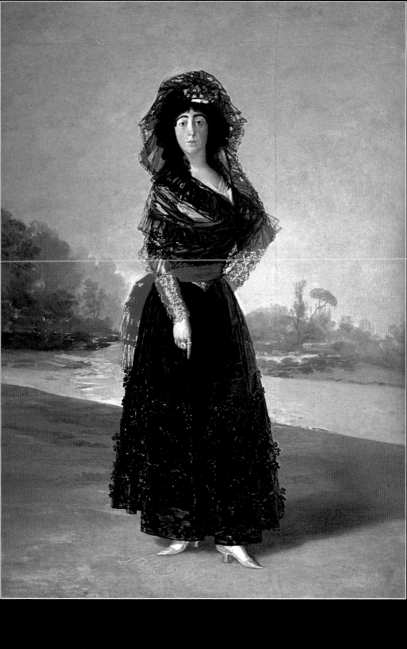

The Duchess of Alba
Francisco de Goya y Lucientes, 1797

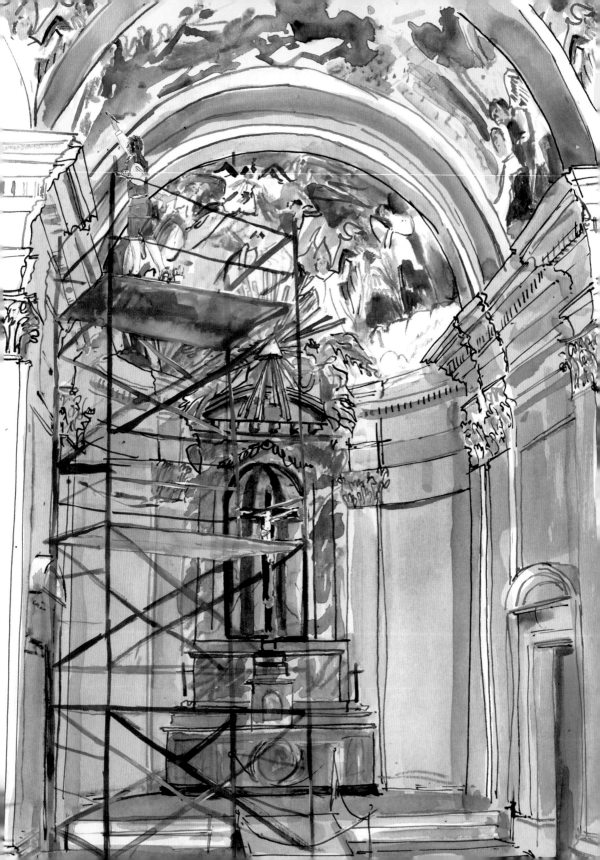

San Antonio de la Florida, 1798

By March 1798 Goya was again strong enough to take on large projects, and he was commissioned to paint the ceiling frescoes for the recently built church of San Antonio de la Florida in Madrid. His friend Gaspar Melchor de Jovellanos, Minister of Grace and Justice, whose portrait Goya had painted earlier in the year, probably secured the commission for him.

This was a royal chapel and not open to the public. Goya would not face the problems he had in Saragossa, and had a certain level of freedom.

Goya's deafness would have affected his balance, so it was risky to be working on scaffolding nine metres above the ground, but he worked fast – it took him four months to complete the work. Included in the allowance was the cost of an assistant, Asensio Juliá, who became a friend and would later help Goya with his *Caprichos* series. Goya was provided with a coach to take him to and from the church every day; it cost almost as much as that of the high-quality materials.

In the dome Goya painted a miracle of the Portuguese Franciscan saint Anthony of Padua, whose father was wrongly accused of murder. Goya transposed the scene from a thirteenth-century Lisbon criminal court to eighteenth-century Madrid, with a mountainous landscape as the setting and crowds of onlookers, all drawn from Madrilenian types such as those that appeared in his tapestry cartoons. The legend tells how Anthony flew through the air from Padua to Lisbon to bring the victim back to life and identify the real murderer, whom Goya shows escaping through the crowd.

In the pendentives Goya painted putti drawing back a curtain, and under the arches the angels appear as girls. The church site had been a popular place for picnics, and Anthony was patron saint of young women.

In 1919 Goya's remains would be placed in this chapel, and in 1928 an identical chapel would be built next to it to allow the original to become a museum dedicated to the artist.

The Osunas

The aristocratic patrons most appreciative of Goya's work were the Duke and Duchess of Osuna. The duchess was a prominent *ilustrado* and her social gatherings were attended by the most important scientific and cultural figures. The duke was patron of the Royal Company of Printmakers and Honorary Academic of the Royal Academy of Fine Arts.

The Osunas were also major patrons of the theatre, and frequently held plays in the private theatre on their country estate. While embracing new science, they also enjoyed the world of fantasy. They were particularly interested in witchcraft and owned a copy of *Malleus Maleficarum* (first published in 1487), a treatise on the prosecution of witches and a guide in previous centuries for large-scale witch-hunts and burnings of women. When the Osunas commissioned Goya to produce a series of six paintings on the theme of witchcraft, they wanted to ridicule the belief and state their position as enlightened thinkers who were beyond such superstition.

Still, as this powerful painting demonstrates, both the Osunas and Goya were fascinated by witches and witchcraft. In *Witches' Flight*, three half-naked witches bite and suck a hapless naked man like malignant insects, while rising into the air. Symbolizing the witches' fate of being burnt at the stake, flames entwine themselves like serpents around their pointed penitent's hats, called *corozas*, worn by the accused at the tribunals of the Inquisition. The *ilustrados* blamed the Church and Inquisition for fostering a fear of – and therefore a belief in – witchcraft. Below the flying witches, a peasant covers his head with a cloak while making a sign against the evil eye, and another throws himself to the ground in fear. A donkey, a symbol of stupidity, underlines the idiocy of the whole scene from a rational point of view, but the image is still terrifying.

The subject matter was no doubt derived from the theatre of horror, which was very popular at this time.

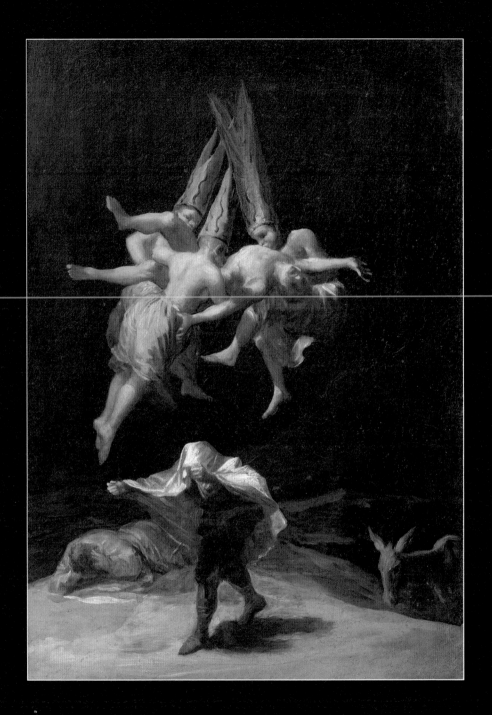

Witches' Flight
Francisco de Goya y Lucientes, 1797

Oil on canvas, 43.5 × 30.5 cm (17¼ × 12 in)
Museo del Prado, Madrid

Street culture

Goya lived in the heart of Madrid's theatre district and was a keen theatre-goer.
In particular he loved the informality of the teatrillos (little theatres).

CALLE del DESENGAÑO

Linterna magica
LA BRUJA de ENDOR

el ORÁCULO DE LA CABEZA parlante

LOS PERROS QUE BAILAN !!!

TEATRO DEL PRÍNCIPE
Hechizado por la fuerza

ESPECTÁCULO de LUZ

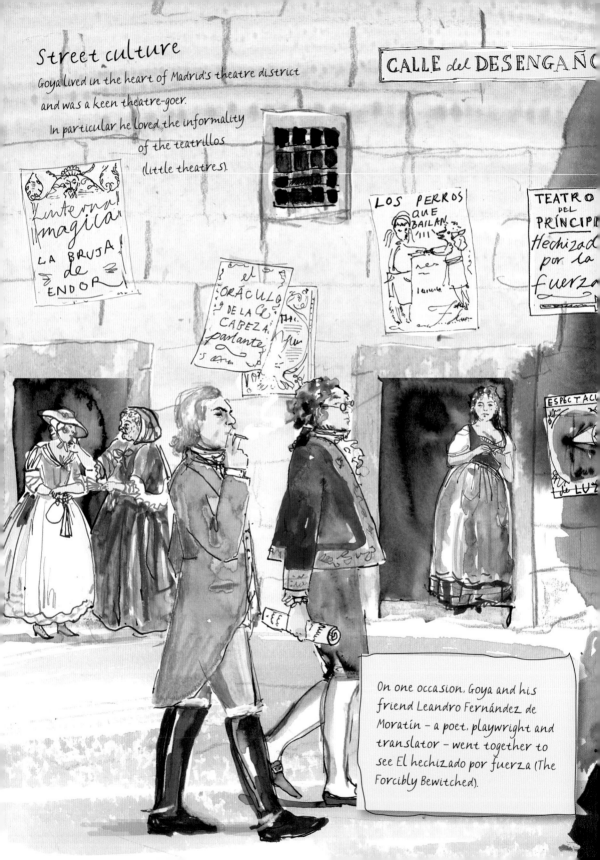

On one occasion, Goya and his friend Leandro Fernández de Moratín – a poet, playwright and translator – went together to see El hechizado por fuerza (The Forcibly Bewitched).

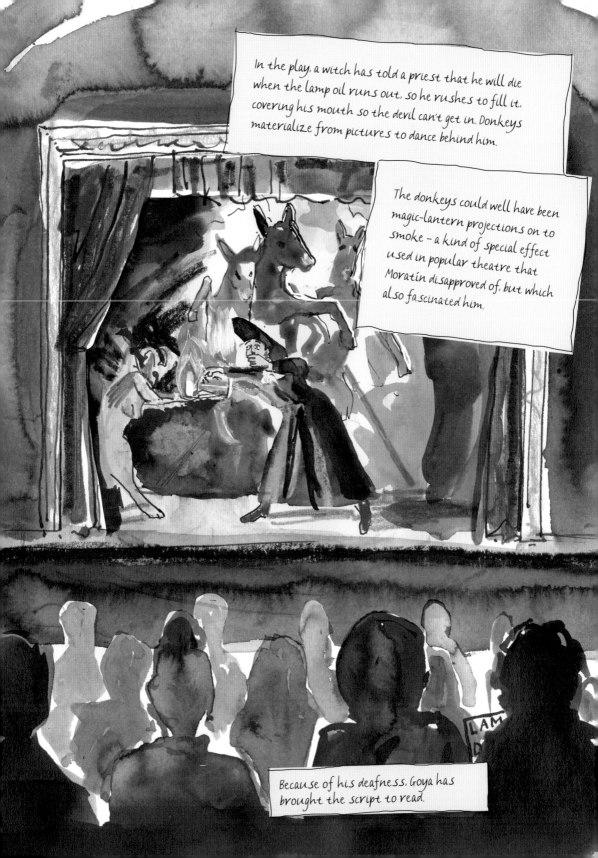

In the play, a witch has told a priest that he will die when the lamp oil runs out, so he rushes to fill it, covering his mouth so the devil can't get in. Donkeys materialize from pictures to dance behind him.

The donkeys could well have been magic-lantern projections on to smoke – a kind of special effect used in popular theatre that Moratín disapproved of, but which also fascinated him.

Because of his deafness, Goya has brought the script to read.

To sleep, to dream

Perhaps inspired by William Hogarth's narrative print series, Goya's most famous print series, *Los Caprichos* (The Caprices), consisted of 80 satirical etchings and aquatints. Goya originally thought of the images as dreams, and the word 'dream' appears on a number of the preparatory sketches he made for the series. On one print he gave the legend *Idioma universal* (universal language), reinforcing his intention that these satirical images could be understood by anyone.

In some of the prints Goya gave people animal features. This pan-European tradition goes back to Aesop's fables and was used by poets of Goya's time. Goya advertised *Los Caprichos* for sale in the newspaper *Diaro de Madrid* on 6 February 1799, and the prints were sold from a perfumery and liquor shop below his apartment in the aptly named Calle del Desengaño (Street of Disenchantment).

In *Capricho* 43 Goya depicts himself slumped at his desk, on the side of which is written 'The Sleep of Reason Produces Monsters'. Flying bats and owls, creatures of the night, emerge from behind him. Some of the owls have faces that resemble humans wearing glasses. One owl is prodding Goya with a kind of pencil. Perhaps 'dream of reason' refers to the Enlightenment's fascination with science. As science seemed to overturn the authority of the Church and religious revelation, it too took on a strange new, marvellous power. The animals in the picture could all be considered escapees from a naturalist's cabinet of stuffed curiosities. The bat – a flying animal – is a timeless object of fascination. The Iberian lynx lived wild on the Duchess of Alba's vast estate; and indeed the lynx in this print may represent her.

The reduced palette – the raw black – intensifies the nightmarish mood and confers a sense of urgency. At the same time, it is the same kind of palette used in the zoological illustrations from the royal collection. The black-and-white graphic was also the language of the popular press – such as the Revolutionary French pamphlets that the Duke and Duchess of Osuna, and other *ilustrados*, read.

But one is also reminded of the theatre – the silhouetted bats have the ghostly quality of phantasmagoria effects. Goya would come to use black a lot. It became an expressive, almost radical tool in unveiling uncomfortable realities and social injustices.

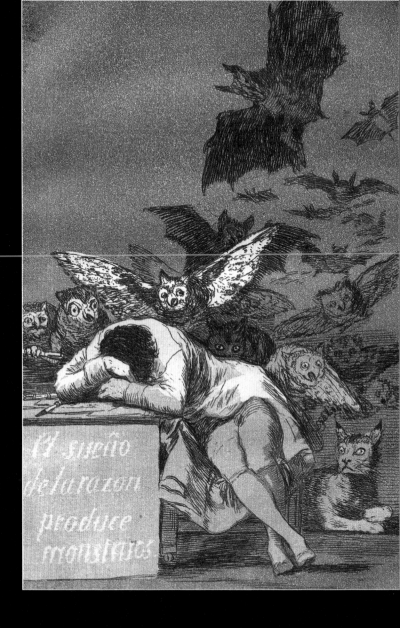

The Sleep of Reason Produces Monsters,
number 43 from *Los Caprichos*
Francisco de Goya y Lucientes, 1799

Engraving and aquatint, 21.4 × 15 cm (8⁷⁄₁₀ × 5¹⁵⁄₁₆ in)
National Gallery of Art, Washington, D.C.
Rosenwald Collection 1943.3.4711.qq

Jovellanos and peepshows

Goya made two drawings of peepshows. In one of them a man splits his trousers peering through the hole and a woman smirks while peering at his naked backside. On it he wrote '*Tuti li mundi*' ('The whole world'), which was the name given to peepshows and magic-lantern shows. It is reminiscent of another drawing from one of his letters, in which a man shows his naked backside with an eye in place of his anus, accompanied by the legend: 'They are looking at what they can't see.'

The more puritanical *ilustrados* disapproved of these peepshows and magic lanterns as well as of '… puppets and grotesque figures, clowns, harlequins and tightrope dancers'. The melancholy minister of Grace and Justice (and Goya's friend), Jovellanos, produced a report on popular entertainment calling for freedom and fun, but he believed these shows did not truly make people happy. He wanted the people to be happy, but as a social reformer he believed he knew better than they what would be good for them. Goya, however, was not so puritanical, and clearly saw such antics and entertainments as very human.

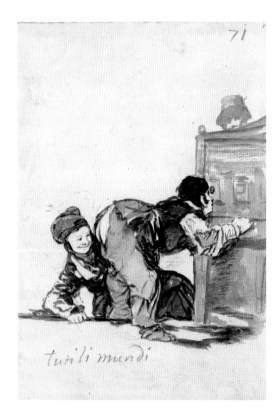

Francisco de Goya y Lucientes
Tuti li mundi (The whole world),
c. 1808–14

Album C, Folio 71
Pen, brush and ink with wash and crayon
or chalk on paper, 20.7 × 14.4 cm
(8⅛ × 5¹¹⁄₁₆ in)
The Hispanic Society of America,
New York

Funny caricature

Goya used obscenity as a comic device in *Los Caprichos*, but when he criticized hypocrisy and corruption in the Church through this kind of traditional anti-clerical imagery he was treading on dangerous ground. He was reported to the Spanish Inquisition and had to remove them from sale.

One of Goya's anti-clerical *Caprichos*, 'They are hot' (a pun for 'on heat'), shows some monks eating soup at a table. However, the preparatory drawings were much more explicit. One, inscribed 'Funny caricature', shows a monk with such a large phallic nose that he needs to prop it up with a crutch. Goya is mocking the vow of celibacy.

The nose/penis association was ubiquitous in Spanish literature. In *To a husband* Quevedo mocked a jealous husband who had cut off the nose of his wife's lover:

> ... Your wife has lost nothing by this, if you have noticed, since the other is still there with which to offend you again.

Goya was not the first visual artist to use this satirical motif (there were cruder examples in popular prints), but for the *ilustrados* it had political connotations, so Goya was taking risks, perhaps counting on the protection of his aristocratic patrons. The prints appealed to the Osunas in particular, who bought four of the best examples from the first print run, and at a higher price than he had asked.

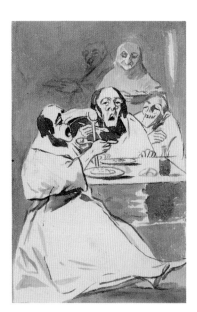

Francisco de Goya y Lucientes
Caricatura Alegre, 1796–97

China ink and wash on paper,
23.2 × 14.2 cm (9⅛ × 5⅔ in)
Museo del Prado, Madrid

The Prince of the Peace

In 1803 Goya sold the remaining 240 *Caprichos* prints and copper plates to the king in exchange for a pension for his son. Perhaps this afforded him some protection from the Inquisition, but this was not the only time that Goya's work came to their attention. A reclining nude, painted for the prime minister Manuel Godoy, was to cause him more problems later on, but for the time being he was occupied with painting portraits of Godoy and his wife.

A vain and ambitious man, Godoy was educated for a military career like his hero Napoleon. He entered the Royal Bodyguard aged 17, and his rise to power was vertiginous, from cadet to duke in four years. He had ingratiated himself with the king and queen to such an extent that their triangular relationship became known as 'the Holy Trinity' and he was widely believed to be Queen Maria Luisa's lover.

In 1792 Charles IV made him prime minister, but his failure to save the king of France from the guillotine went against him, since it was believed by the Spanish public that the government should save Charles IV's first cousin. Spain, allied with Britain, then declared war on France, but when in 1795 Godoy signed a peace treaty with the French, public opinion applauded him as the 'Prince of the Peace'.

In this painting of 1801 Godoy has just won a battle against the Portuguese. He lounges in military dress uniform, holding a document, perhaps the notice of surrender. By this time the French Revolutionary government had come to a bitter end and France was under the control of Napoleon, whose imperialist ambitions knew no bounds. Godoy signed various treaties with Napoleon, whom he admired and emulated. He was his ally against the British (who were now allies of the Portuguese). One of these treaties offered Godoy the position of Prince of the Algarves – in which he would be the de facto ruler of southern Portugal. However, Napoleon had no intention of promoting Godoy: he wanted Portugal first and Spain after that. Godoy's vanity and incompetence set the stage for Napoleon to invade Spain with practically no resistance from its leaders.

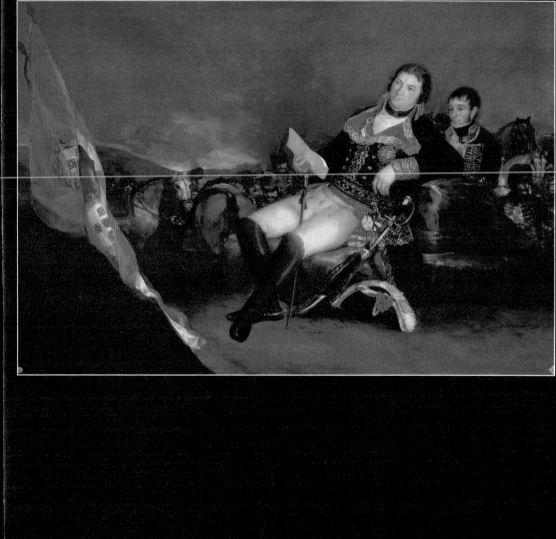

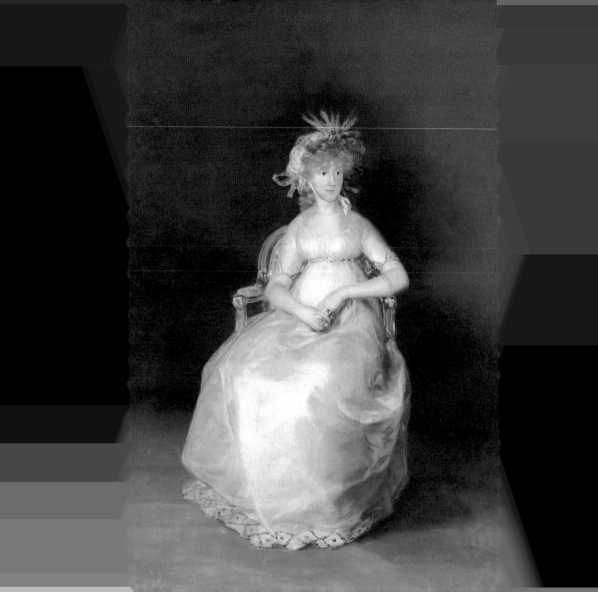

The unlucky princess

Godoy was in Sanlúcar during the summer of 1796, at the same time as Goya. There he met his lifelong lover, Pepita Tudó, who was 17 at the time. A year later, to give Godoy respectability, the queen arranged his marriage to her husband's second cousin María Teresa, Countess of Chinchón.

Once, in the homely atmosphere of the court of Don Luis de Borbón, where Goya had felt part of the family, María Teresa had been the wide-eyed, curious little girl watching Goya painting while her parents played cards and her mother had her hair done. It must have been a sad thing for Goya to see her married off to Godoy, particularly as Pepita Tudó continued to live with the couple. This was one of the unhappy marriages of convenience that Goya would refer to in *Los Caprichos*.

In Goya's portrait of her, María Teresa appears fragile, a modest girl in a simple empire-line white silk dress, decorated with dots, wearing a bonnet and looking pensively to the left. The sheaves of corn in her hair are a symbol of fertility – she was pregnant at the time. The way her curly blonde hair escapes from her bonnet evokes the child Goya once knew. Her ring has an enamel portrait of Godoy with a sash.

Goya's honourable and principled friend Jovellanos was scandalized when invited to dinner at Godoy's house:

> On his right-hand side was the princess, to the left, next to him, was that Pepita Tudó. This spectacle filled me with anxiety; it was more than I could bear. I could not eat or speak. I could not keep calm; I fled from that place.

A year after the marriage Jovellanos was ejected from his post by Godoy and later imprisoned. Writing from exile to Manuel Bayeu in 1807, he asked after Goya, sending an embrace to '… this gentleman for whom I will always profess the most affectionate friendship'. Jovellanos died four years later in his native Asturias.

The *maja* pictures

Godoy lived in a modern palace in Madrid, where he kept
over a thousand works of art, 26 of them by Goya. The collection
included a hidden room of female nudes, which was accessible
only by special invitation. Among these was Velázquez's sensual
Venus and Cupid, a back view of a reclining female nude, which
Godoy had acquired from the Duchess of Alba.

Around 1800 Godoy commissioned a painting of a reclining
nude *maja* from Goya. However, the subject is no Venus, but a
girl from the streets of Madrid, and probably the first female
nude in Western art to be painted with pubic hair. Moreover,
she has the features of Godoy's lover, Pepita Tudó. Her cheeks
are rouged and her eyes painted. Although an object of desire,
she is in control and seductively flaunts her nudity.

Not long after, Godoy asked Goya to paint a clothed *maja* in
exotic harem clothes. It is believed that the paintings were placed
back to back on a swivel, so that he could surprise his guests.

In 1815, after the Peninsular War, these paintings would
cause considerable problems for Goya. They were seized
by the Inquisition, and Goya was called to a tribunal in order to
'... declare if they are his work, for what motive he painted them,
on commission to whom and to what end they were proposed ...'.
Goya may not have been forced to keep this ominous
appointment, but the threat of the Inquisition also never
entirely went away.

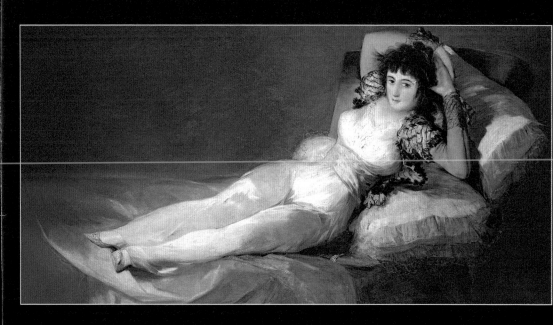

The Clothed Maja (*Maja Vestida*)

Francisco de Goya y Lucientes, *c.* 1807–8

Oil on canvas, 95 × 190 cm (37⁷⁄₁₆ × 74¹³⁄₁₆ in)

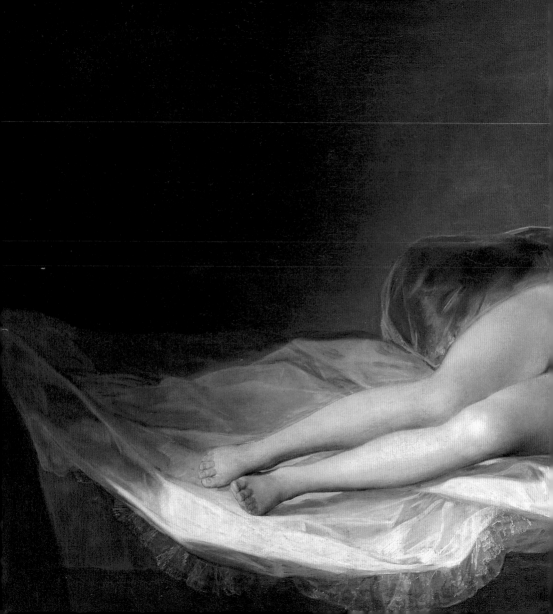

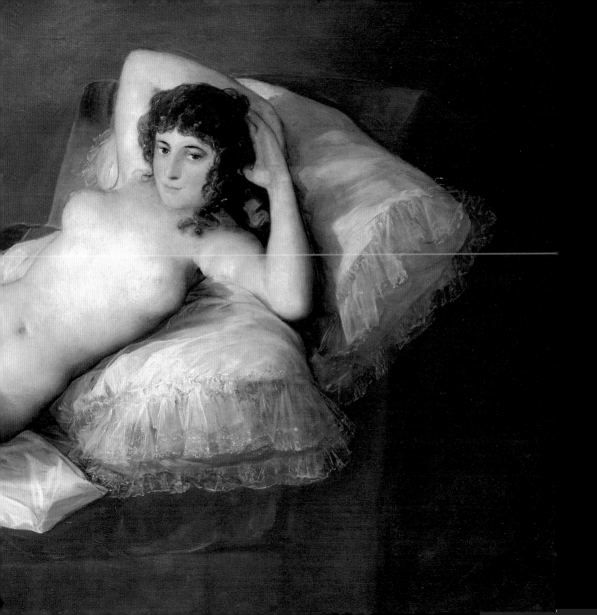

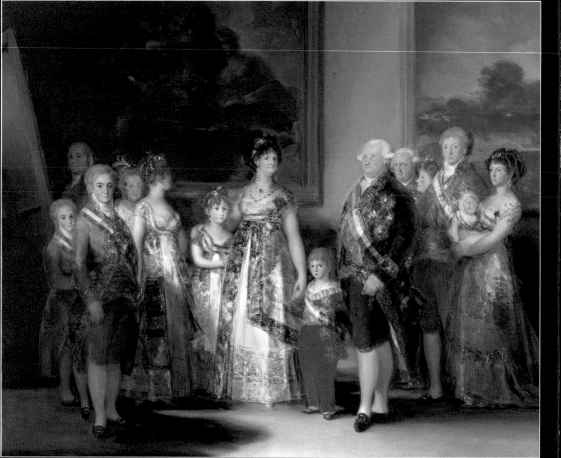

King Charles IV's day

Regal brekkie

Morning hunt

Royal lunch

Afternoon hunt

Luxsory hour of state matters

Royal dinner

Picturing indolence

It was probably Godoy who commissioned Goya to paint a group portrait of the royal family to be shown to the French ambassador, Napoleon's brother Luciano, when he visited the court in 1800.

Although the painting is not exactly flattering, the king and queen were delighted with it. Goya was continuing the Spanish tradition of veristic court portraiture, and the queen's vulgarity was real: her heavy gold earrings and necklaces; her false teeth as she smiles too widely; her plump arms, of which she was proud. On the other hand, the portly and somewhat pompous king, posing in his medals, has a vacant look on his pink face. This was an indolent king who was happy to leave the state in his wife's and Godoy's hands.

Goya knew that placing Maria Luisa centre stage, with her youngest children either side, would appeal to her vanity. The boy, Francisco de Paula, holds both his parents' hands, perhaps to counteract rumours that he was actually Godoy's son. The young man in blue on the left is the future Ferdinand VII. His younger brother Carlos, in red, puts his hands on Ferdinand's flanks, as if to push him forward to be the next king. Carlos would later challenge his brother for the throne.

The faceless woman looking at a painting on the back wall is the as yet unknown future wife of Ferdinand.

Revolt and isolation

In December 1807 Napoleon helped Ferdinand to conspire against his parents. After that failed, Napoleon began preparing the invasion of Spain. When news of the invasion reached Godoy and the king and queen, they all fled to the Palace of Aranjuez to organize an escape. But on 17 March 1808 Ferdinand's supporters staged an uprising against Godoy, and marched on Aranjuez.

Godoy was found two days later hiding in the attic of the palace among rolled-up carpets.

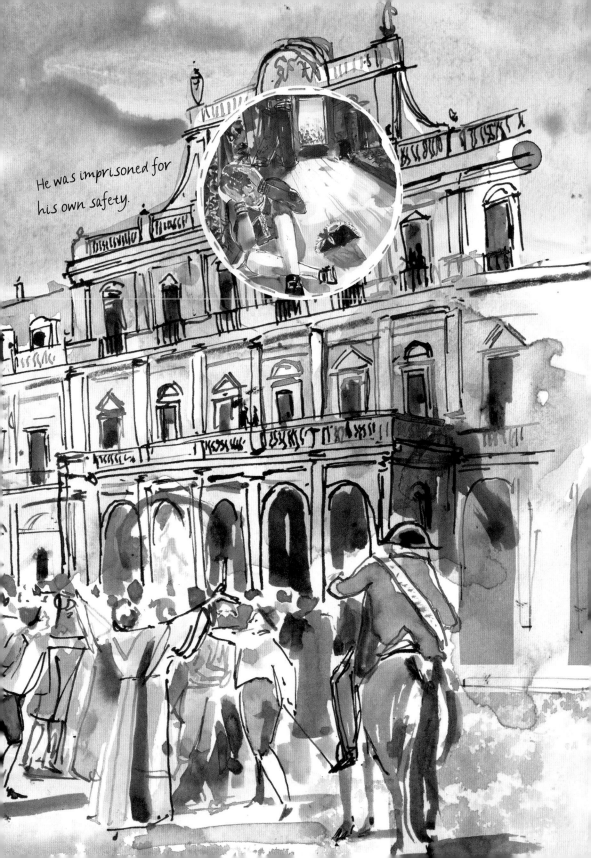

He was imprisoned for his own safety.

3 May 1808

With the fall of Godoy the king's position was unsustainable. He abdicated in favour of his son, but Ferdinand did not remain king for long. In April Napoleon called him to Bayonne, on the French/Spanish border, where his parents and Godoy were already under arrest. There he was forced to return the crown to his father, who passed it to Napoleon. On 2 May Napoleon's lieutenant-general, Murat, at the head of the French army marched on Madrid.

After the French took Madrid, the Spanish army was in total disarray. No one was left in the Spanish government to give orders. From the Royal Palace the city's new ruler, General Murat, began ordering the detention and execution of those suspected of anti-French sentiments. As the hill on which the executions took place was visible from Goya's home, and as he also owned a telescope, he might have witnessed these executions.

Painted six years after the event, Goya's famous painting of the first night of executions shows the firing squad taking aim with their rifles. Seen from the back, they resemble a machine, a uniform row of faceless executioners. The shootings went on all through the night; in Goya's painting the ground is piled with bodies and stained with blood.

Each of the victims stumbles to his death alone, in fear, despair, bewilderment and defiance. Two men face the bayonets; beside them is a praying monk, a victim, not a confessor. The focus is on a man in a white shirt and yellow breeches, lit up by a cube-shaped lamp. The whites of his eyes contrast with his dark skin. Defiantly, he throws his arms in the air, like a crucifixion, and his open palms bear the *stigmata*, the wounds of Christ. Goya commemorates the brave but futile 'glorious insurrection' as martyrdom, not victory. This is a new kind of war art.

The large cubic lamp is startling. This is not the divine golden light of Renaissance art that mysteriously bathes biblical figures. Modern, as stark as the electric bulb, the lamp is there to perform a necessary function, to illuminate. Pablo Picasso would later also focus on the lamp:

> And then there is that enormous lantern on the ground, in the centre. That lamp, what does it illuminate? The fellow with upraised arms, the martyr. You look carefully: its light falls on him. The lantern is Death. Why? We don't know. Nor did Goya. But Goya, he knew it had to be like that.

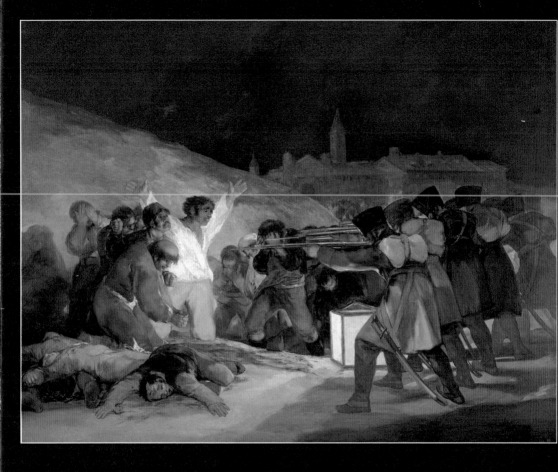

The Third of May, 1808
Francisco de Goya y Lucientes, 1814
(after restoration)

Oil on canvas, 268 × 347 cm (105½ × 136⅜ in)
Museo del Prado, Madrid

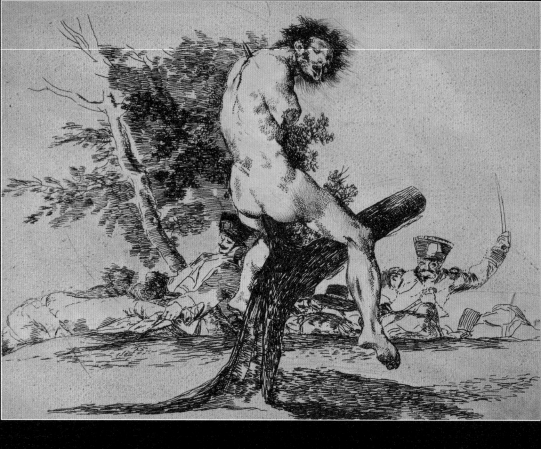

This is worse, number 37 from
The Disasters of War
Francisco de Goya y Lucientes, 1810–20

Published 1863. Etching and aquatint, 15.5 × 20.5 cm (6⅛ × 8¹/₁₀ in)
Yale University Art Gallery, The Arthur Ross Collection 2012.159.37.38

The Disasters of War

In October 1808 Goya accompanied General Josef Palafox to Saragossa, under siege between June and August, '… to see and examine the ruins of that city, with the aim of painting the glorious deeds of the citizens, something I could not excuse myself from, as I am so interested in the glory of my home town'.

During this time he worked on the drawings that were later to be used for his most disturbing indictment of man's inhumanity to man, *Los Desastres de la Guerra* (*The Disasters of War*).

In November he fled to Fuendetodos, and when the second siege began in December he destroyed some of his sketches in case they fell into French hands.

He was called to Madrid in May 1809 to serve Spain's new ruler, José I, brother of Napoleon. He painted a portrait of the 'intruder-king', as part of an allegory, while secretly working on the *Desastres* drawings. He intended to publish them as a print series, although this did not happen in his lifetime.

Among the atrocities Goya represented is this mutilated body based on the Belvedere Torso, the Classical sculpture of Hercules he drew while in Italy. Goya shows the abomination that is war, but at the same time interrogates the role of art in times of barbaric horror. Traditionally war art had been about heroism, but for Goya it was a means of reporting the truth. The prints are ground-breaking as artworks and disturbingly realistic.

On one of the images Goya wrote: 'I saw this – and this too' – experience, not imagination.

Belvedere Torso, 1st century BCE
Marble, height 156.5 cm (61⅝ in);
214 cm (84¼ in) with base
Museo Pio-Clementino, Vatican City

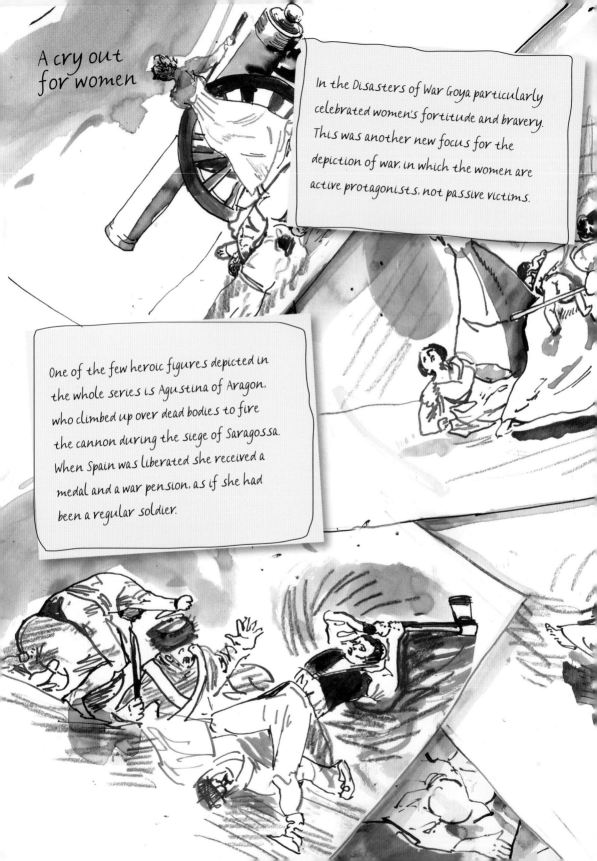

A cry out for women

In the Disasters of War Goya particularly celebrated women's fortitude and bravery. This was another new focus for the depiction of war, in which the women are active protagonists, not passive victims.

One of the few heroic figures depicted in the whole series is Agustina of Aragon, who climbed up over dead bodies to fire the cannon during the siege of Saragossa. When Spain was liberated she received a medal and a war pension, as if she had been a regular soldier.

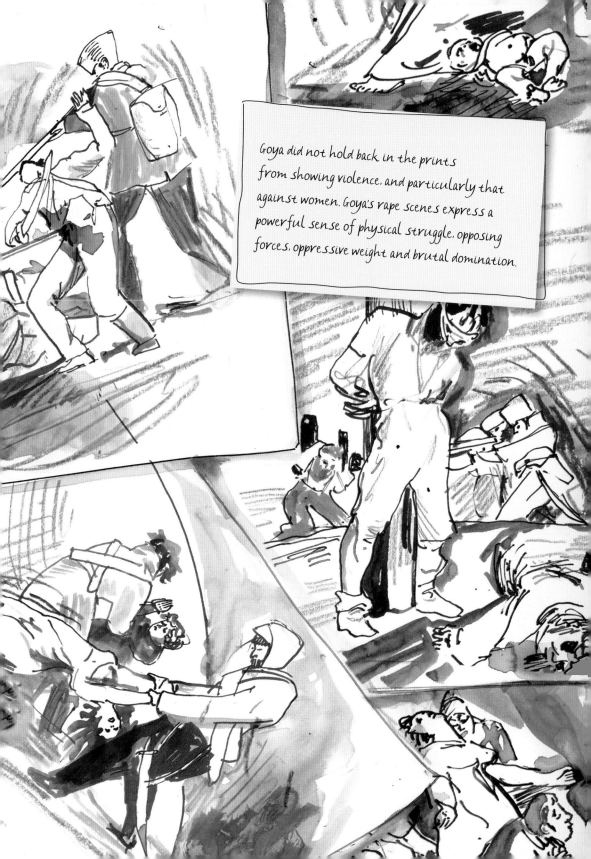

Goya did not hold back in the prints from showing violence, and particularly that against women. Goya's rape scenes express a powerful sense of physical struggle, opposing forces, oppressive weight and brutal domination.

Ferdinand VII

Near the end of the war, in June 1812, Goya's wife died at the age of 65. While coming to terms with this, Goya produced a series of dark paintings of dead birds, rabbits and meat, subject matter deriving from still-life painting traditions symbolizing the brevity of life.

In August the Duke of Wellington entered Madrid with the Anglo-Hispanic-Portuguese allied troops. Goya painted him on horseback. The picture was on show at the Royal Academy in Madrid for a week. A year later, after losing the battle of Vitoria, the French troops retreated from Spain for good.

Meanwhile the princes Ferdinand and Carlos were kept under house arrest in the Chateau of Valençay, in France. Ferdinand embroidered an altar cloth for the local church. He was freed in December 1813 after signing a treaty of alliance between Spain and France against Great Britain. The following year Napoleon was dethroned and in June 1815 he was defeated at the Battle of Waterloo.

Meanwhile, in distant Cadiz, a group of *ilustrados* had met to draft a constitution limiting royal power, ending the feudal system, prohibiting torture and establishing freedom of the press. They also intended to abolish the Spanish Inquisition.

In March 1814 Ferdinand finally crossed the border into Spain. He feigned acceptance of the Cadiz Constitution, but two months later revoked it, arrested the leaders and entered Madrid as king by divine right. Known as 'the desired one' by the people, who initially blamed the *ilustrados* for their woes, there was nothing desirable about Ferdinand. Once he was on the throne, among other absolutist restructurings of society, he reinstated the Jesuits and the Inquisition.

Goya was still painter to the king. He executed a number of portraits of Ferdinand VII, but all were based on one sketch done in a single sitting. The king's stubborn, resentful and suspicious expression is no doubt an accurate portrait of the man, whose grotesque entourage consisted of toadies, flatterers and other disreputable individuals. Dwarfed by his coronation robes, he appears ridiculous, as if playing a comical role in a farce.

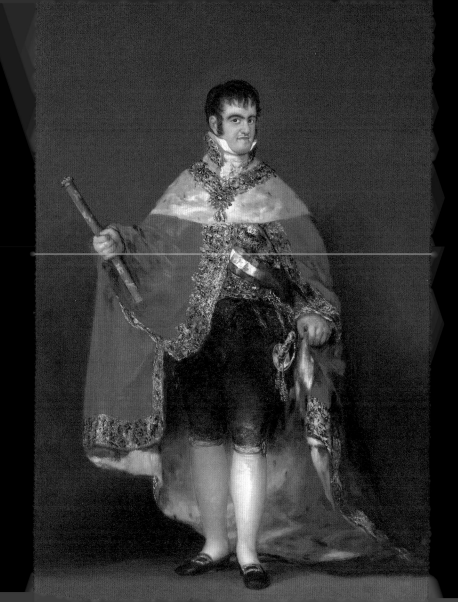

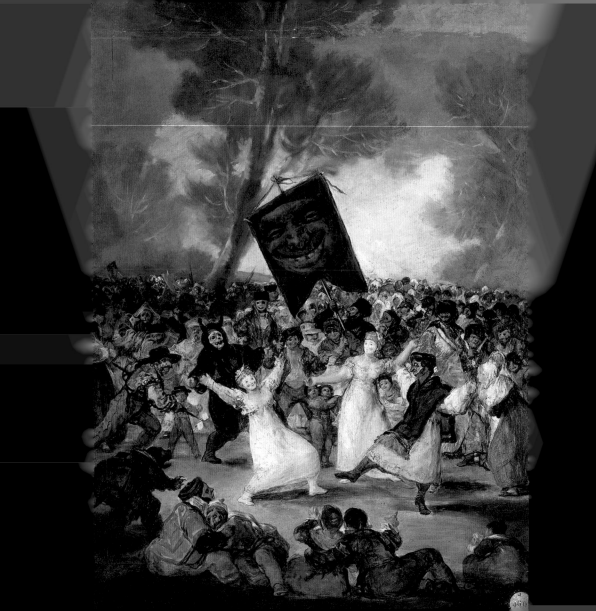

The Burial of the Sardine

In May 1814, the same month in which he revoked the Cadiz Constitution, Ferdinand VII restored the powers of the Inquisition. Any hope of progress and reform in Spain was extinguished.

At about this time Goya painted a Carnivalesque scene. Its apocryphal title relates it to a specific ritual marking the end of Carnival, but it bears little relation to the painting. Here a crowd watch figures in fancy dress dancing under a banner bearing a grotesque grinning mask that has a double meaning, since this scene masks an earlier version, which may be made out in raking light. Ghostly figures appear to dart through the crowd and a skeleton dances behind the mask on the banner, with the word *Mortus* (Death) above.

The underpainting resembles one of Goya's anti-clerical drawings of monks and nuns dancing under a banner bearing symbols that include a papal tiara and the word *Mortus* above. Most probably they are celebrating the restoration of the Inquisition.

In November the Inquisition seized the *Majas* and began their investigation into Goya. Moreover he was also under investigation by the 'Commission for the Purification of Employees of the Royal House' regarding his services as a painter to José Bonaparte. Under these circumstances Goya may have considered destroying this painting, but instead he disguised it.

Fortunately the Commission cleared Goya of any wrongdoing, based on his argument that even though the 'intruder-king' had awarded him a medal, he had never worn it. Moreover, he had recorded and published the horrors of the French invasion and the ruins of Saragossa.

Goya somehow managed also to evade the Inquisition – although it is not known exactly how. Nevertheless, as an *ilustrado* his situation in the new reactionary Spain remained precarious.

Tauromaquia

Charles IV had suppressed bullfighting in 1805 in order to promote an image of Spain as an enlightened country. In 1811 José Bonaparte restored the *fiesta*, since he wanted to win Spanish hearts and minds.

Goya had always been fascinated by bullfighting. He practised it as a young boy, and before the ban he had followed the bullfights with a passion. But bullfighting had become a contentious subject; the *ilustrados* were divided, and some heartily disapproved of the savagery. Undeterred, perhaps because he had Moratín's support, Goya indulged his passion and embarked on a series of bullfighting prints. Sold as a complete volume, *Tauromaquia* was intended to give 'an idea of the initial stages, development and present state of these celebrations in Spain'. The book was less successful commercially than he had hoped.

In the twentieth century, the art critic Michel Leiris would compare the bloodthirsty sport to a religious festival that puts us 'in touch with what is most intimate ... if not most impenetrably hidden, about ourselves'. Goya's extraordinarily beautiful prints confer significance on the ritual. The austere staging of plate 20 has the quality of a film still. With an acute vision for the significant moment, Goya shows the legendary bullfighter Juanito Apiñani performing the feat for which he was famous. Dangling in the air as the bull butts his pole, Apiñani is both Olympic and pitifully vulnerable. Everything serves the main activity: the bullfighter and the beast are isolated in the otherwise empty ring, the crowd's gaze directs the spectator to the combat, and the diagonal sweep of shadow focuses our attention on those deadly bull horns.

Goya's execution is very different in this series. His expressionist touch – the unfinished look – is abandoned. Instead we have crisp images. The change demonstrates Goya's responsiveness. Brilliantly observed, the sharp definition and stark contrast between light and shadow capture the bright Iberian sun hitting the ring and casting dark shadows. The steely precision of the line reflects the concentration of the fight.

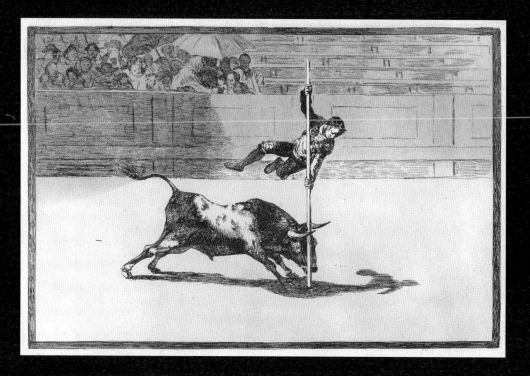

Lightness and Daring of Juanito Apiñani,
number 20 from *Tauromaquia*
Francisco de Goya y Lucientes,
in or before 1816

Etching and aquatint (1st edition impression)
24.5 × 35.5 cm (9⅝ × 14 in)
Yale University Art Gallery,
The Arthur Ross Collection 2012.159.38.20

The House of the Deaf Man

'There is no more troubling –
but fascinating – colour than black.'
Johann Wolfgang von Goethe

In February 1819 Goya bought the aptly named House of the
Deaf Man. He lived there with a younger woman, Leocadia Weiss,
and her daughter Rosario (who may have been Goya's child).
Towards the end of the year Goya became seriously ill and
almost died. One can only imagine his sense of isolation, unable
to hear, confined to his delirious state. When he recovered, Goya
started on the most extraordinary project of his life.

On the walls of his house, a place that is identified with one's soul,
he created his Black Paintings over the next three years. Fourteen
monumental murals spanned the two floors of his house. Hellish
black came into its own, stranding solitary figures in abject gloom
and carving out deep anatomical hollows: devouring mouths, pits
of eye sockets and terrified, gaping pupils. So, at the end of life,
Goya surrounded himself with his own haunting visions.

Some say that Goya had been driven mad by his illness and the
trauma of years of warfare. His raw, feverish execution suggests
a cathartic working process. Unguarded, Goya vivifies anger and
misery on the grandest scale.

The cutting-edge phantasmagoria theatre of Professor Etienne-
Gaspard Robert, also known by the stage name Robertson,
may well have influenced Goya's vision. From 1821 Robertson
performed frequently at Madrid's Teatro del Principe, and his
phantasmagoria was very different from the early magic-lantern
effects that Goya would have known. This was an all-consuming
experience. In the pitch-dark chamber of the theatre, ghostly
apparitions of the dead appeared. Heightening 'the reality effect',
Robertson used smoke to render the figures more diaphanous
and ghostly, and created real filmic movement by mounting his
lantern on wheels, and wheeling the device backwards and
forwards. Robertson's characters loomed towards their audience.
The audience was terrified. People even tried to strike out at the
shadows with their canes.

When Enlightenment thinkers denied superstition and evil forces,
anxiety and fear became internalized. The void – the black
chamber – of Robertson and Goya's Black Paintings could be
read as a metaphor for this inner, angst-ridden reality, and from
it terrible things did indeed emerge.

Saturn

'And now begins modern art'
André Malraux

The most dramatic of the Black Paintings, *Saturn Devouring One of his Sons*, uses the drama of the close-up to bring us face to face with the most appalling flesh-eating horror. On the left side opposite the entrance to the ground-floor room of Goya's house is depicted this ancient Titan who was told by an oracle that his sons would depose him, and so decided to eat them at birth. But his wife, Opis, fooled her husband and exchanged three of the babies, Jupiter, Neptune and Pluto, for stones, which Saturn swallowed. When Jupiter grew to maturity, he deposed his father and cut off his penis. Originally, Goya's Saturn had an erect penis, but when the paintings were transferred to canvas in the mid-nineteenth century this detail was lost. Allegorizing the power of the State, Saturn consumes his own child, echoing the way successive rulers had mindlessly slaughtered the Spanish people.

For the French art theorist André Malraux, Goya's *Saturn* opened the gate to modern art. Salvador Dalí would directly reference Saturn's angular, decaying bones in *Soft Construction with Boiled Beans (Premonition of Civil War)* of 1936, and Goya's painting also anticipated Francis Bacon's cruel anatomy.

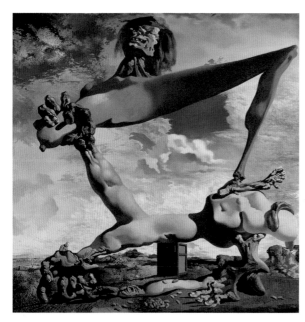

Salvador Dalí
Soft Construction with Boiled Beans (Premonition of Civil War), 1936

Oil on canvas, 100 × 100 cm
(39⁹⁄₁₆ × 39⁹⁄₁₆ in)
Philadelphia Museum of Art.
The Louise and Walter Arensberg
Collection, 1950

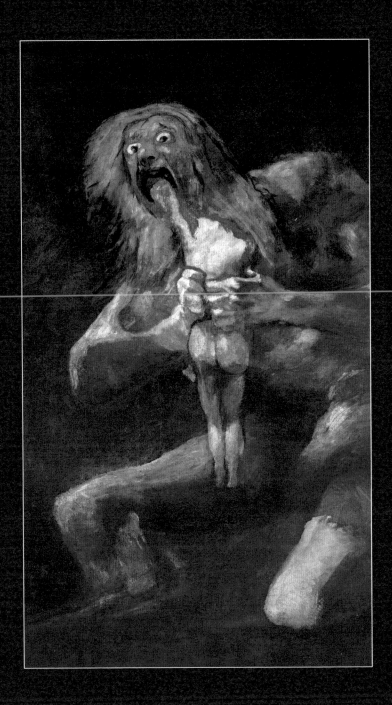

Saturn Devouring One of his Sons
Francisco de Goya y Lucientes, 1821–23

Oil mural transferred to canvas, 143.5 × 81.4 cm (56½ × 32 in)
Museo del Prado, Madrid

Hope and defeat

From 1820 to 1823, while Goya was painting his Black Paintings at the House of the Deaf Man, Spain witnessed one last, brave attempt to establish a government based on Enlightenment ideals. The repressive, reactionary government of Ferdinand VII was forced by a group of young, liberal officers to reinstate a Constitution that was first drawn up in 1812, but squashed by the king's insistence on his divine right to rule as an absolute monarch. Following his *ilustrado* heart, Goya swore an oath of allegiance to the new liberal government and Constitution.

However, in 1823 Ferdinand's troops, supported by the so-called Holy Alliance of European monarchs (a treaty created to defend absolutism and Catholicism), toppled the liberal government, restoring the absolute monarchy. Supporters of the Constitution were persecuted and eliminated. For three months Goya, along with other *ilustrados*, sought refuge at the Royal Hospital in the residence of its chief administrator – the erudite Aragonese priest José Duaso.

Once he could safely leave, Goya returned to the House of the Deaf Man under virtual house arrest enforced by the watchful eye of Ferdinand's repressive regime. Goya was 77 years old and completely broken. Most of his friends and supporters, such as Zapater, Jovellanos, the Duke of Osuna and the Duchess of Alba, were long dead. Of those who survived, many, like Moratín, had fled Ferdinand's repressive regime and gone into exile, while others, like the Duchess of Osuna, had retreated behind the doors and shutters of their homes.

During a general amnesty of liberals in May 1824, Goya wrote to Ferdinand explaining that his doctors had advised him to take the waters in Plombières-les-Bains, France. He was given permission to go.

Goodbye Madrid, goodbye Spain

On 24 June Goya arrived in France with Leocadia and in Bordeaux met his friend Moratín, who described him in a letter to a mutual friend as:

> … deaf, old, clumsy and weak, without knowing a word of French, and without bringing a servant (though no one needs one more than he), and so happy and so eager to see the world.

He never went to Plombières, but a few days later he went to Paris, and stayed with a friend of Moratín. He visited the main sights and went to the *Salon*, and saw other old friends, like María Teresa de Borbón, who had completely separated from her faithless husband, Godoy, and established herself in the French capital (she would die there four years later at the age of 49).

In September, Goya decided to settle in Bordeaux. Although there are few paintings from this final period, it is clear that his fascination with the humanity around him was undimmed. His sketchbooks document everything he witnessed there, from Leocadia and her children to the people on the streets of Bordeaux. He had an affinity for the city's beggars, and particularly for the often ingenious ways they managed to survive on the streets.

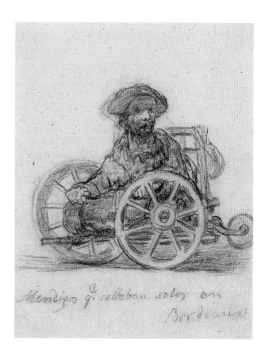

Francisco de Goya y Lucientes
*Beggars Who Get about on their
Own in Bordeaux*, 1824–27

Black chalk on greenish laid paper,
19.4 × 14 cm (7⅝ × 5½ in)
National Gallery of Art, Washington, D.C.
Woodner Collection 1993.51.9

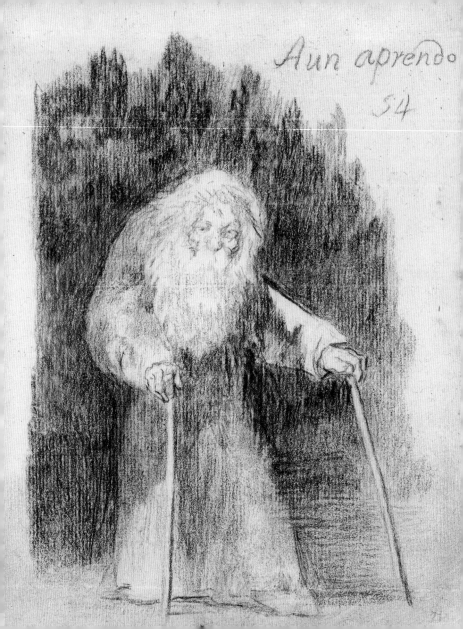

Aun aprendo
54

Goodbye Madrid, goodbye Spain

On 24 June Goya arrived in France with Leocadia and in Bordeaux met his friend Moratín, who described him in a letter to a mutual friend as:

> … deaf, old, clumsy and weak, without knowing a word of French, and without bringing a servant (though no one needs one more than he), and so happy and so eager to see the world.

He never went to Plombières, but a few days later he went to Paris, and stayed with a friend of Moratín. He visited the main sights and went to the *Salon*, and saw other old friends, like María Teresa de Borbón, who had completely separated from her faithless husband, Godoy, and established herself in the French capital (she would die there four years later at the age of 49).

In September, Goya decided to settle in Bordeaux. Although there are few paintings from this final period, it is clear that his fascination with the humanity around him was undimmed. His sketchbooks document everything he witnessed there, from Leocadia and her children to the people on the streets of Bordeaux. He had an affinity for the city's beggars, and particularly for the often ingenious ways they managed to survive on the streets.

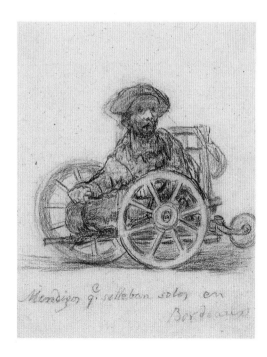

Francisco de Goya y Lucientes
*Beggars Who Get about on their
Own in Bordeaux*, 1824–27

Black chalk on greenish laid paper,
19.4 × 14 cm (7⅝ × 5½ in)
National Gallery of Art, Washington, D.C.
Woodner Collection 1993.51.9

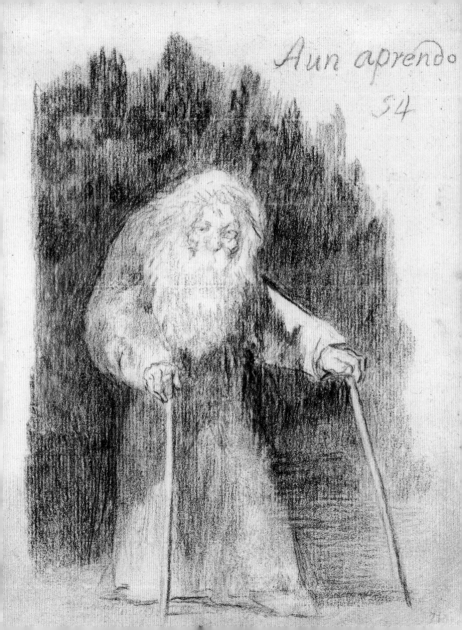

In his old age Goya experimented with new materials and techniques, such as painting on ivory, and the newly invented lithography. In Bordeaux he produced a series of lithographic prints, *The Bulls of Bordeaux*, which, with their strong satirical element, are very different from *Tauromaquia*.

Goya fell seriously ill in June 1825 but recovered by the end of July.

Moratín's letters show his fondness for the cantankerous Goya:

> … sometimes he gets it into his head that he has a lot to do in Madrid; and if they would allow him, he would set off on a chestnut mule, with his cap, his cape, his walnut stirrups, his wineskin and saddlebags.

Goya did in fact return to Madrid in May 1826 to ask for his retirement pension:

> … just as he always organizes his journeys; he's going alone and very displeased with the French, … and if he doesn't arrive, don't be surprised, because the smallest indisposition could leave him stiff in the corner of an inn.

The pension was granted, and by July Goya was back in Bordeaux.

The following year he was once again in Madrid, where he painted his grandson, Mariano. He was in Bordeaux in September and as Moratín reported:

> … Goya is fine, he keeps busy with his sketches, goes for walks, eats and sleeps the siesta …

'I am still learning,' he wrote.

Goya died in Bordeaux in April 1828 at the age of 83.

Acknowledgements

The author thanks all those people in England and Spain who have supported her Goya studies for over thirty years. She would also like to thank the series editor, Catherine Ingram, for her enthusiasm and guidance in shaping the material.

Bibliography

Jeannine Baticle, *Goya: Painter of Terror and Splendour* (Thames & Hudson, 1994)

Wendy Bird, 'Oh Monstrous Lamp! Special Effects in Goya's "A Scene from El Hechizado por Fuerza" in the National Gallery, London', *Apollo*, March 2004, pp. 13–19

Helen Cowie, 'Sloth Bones and Anteater Tongues: Collecting American Nature in the Hispanic World (1750–1808)', *Atlantic Studies, Global Currents*, 8:1, pp. 5–27

Paula De Vos, 'Natural History and the Pursuit of Empire in Eighteenth-Century Spain', *Eighteenth-Century Studies*, Vol. 40, No. 2 (Winter, 2007), pp. 209-239

Pierre Gassier and Juliet Wilson Bareau, *Goya: His Life and Work* (Thames & Hudson, 1971)

Nigel Glendinning, 'Goya's Patrons', *Apollo*, October 1981, pp. 236–47

Robert Hughes, *Goya* (Harvill Press, 2003)

Juan José Junquera, *The Black Paintings of Goya* (Scala, 2003)

Alfonso E. Pérez Sánchez and Eleanor A. Sayre, *Goya and the Spirit of Enlightenment* (Bulfinch Press, 1989)

Sarah Symmons, *Goya* (Phaidon, 1999)

Janis A. Tomlinson, *Francisco Goya: The Tapestry Cartoons and Early Career at the Court of Madrid* (Cambridge University Press, 1989)

Francisco Calvo Serraller, ed., *Goya y el infante Don Luis: el exilio y el reino* (Patrimonio Nacional, Madrid, 2012)

Wendy Bird

Wendy Bird teaches at the Open University, among other institutions. Since she first discovered Goya's prints at art college, the artist has been a constant focus of her study. She has been involved in Spanish street theatre, music and film and is herself a practising artist.

Sarah Maycock

Since being chosen by It's Nice That as one of the most promising graduates of 2011, Sarah Maycock's clients have included the likes of Sony Music, *The Times*, the BBC, Waitrose, *Jamie Oliver Magazine*, Liberty, MiH Jeans, *The Financial Times*, *The Guardian*, Pentagram, Quadrille Publishing, Conran Design and *Kinfolk*.